Artists in Focus

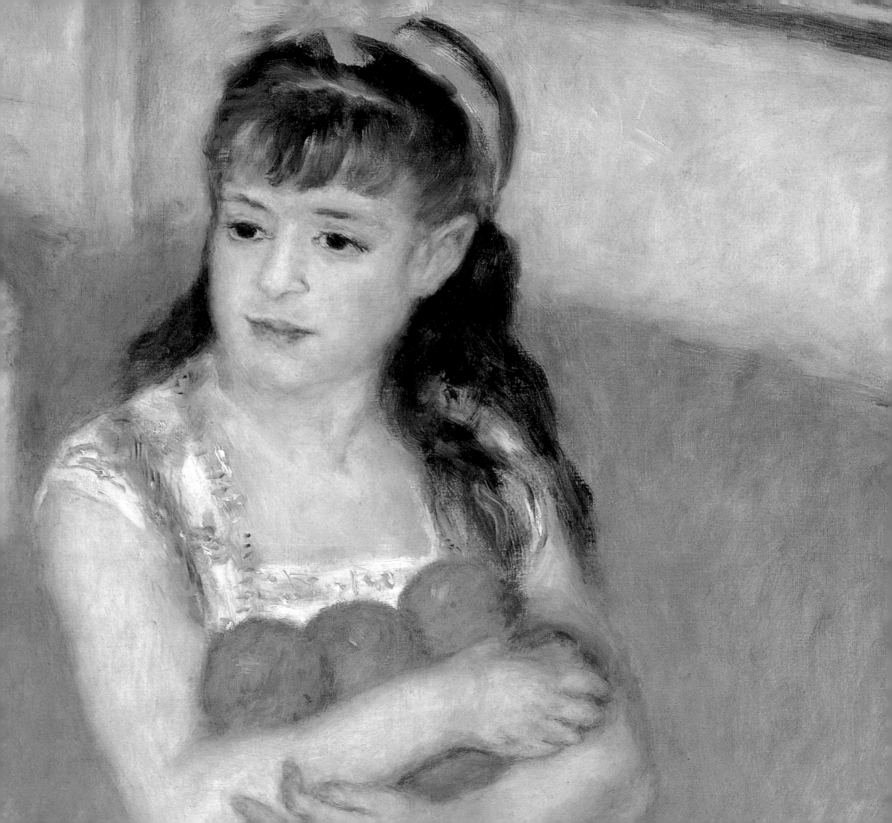

Renoir

Douglas W. Druick

THE ART INSTITUTE OF CHICAGO

Distributed by Harry N. Abrams, Inc., Publishers

Produced by the Publications Department of The Art Institute of Chicago, Susan F. Rossen, Executive Director
Edited by Britt Salvesen
Research assistance by Tracie Nappi
Production supervised by Daniel Frank and Sarah Guernsey

Designed and typeset by Joan Sommers Design, Chicago
Color separations by Professional Graphics Inc., Rockford, IL
Printed and bound by Amilcare Pizzi, Milan, Italy

Distributed in 1997 by Harry N. Abrams, Inc., a Times-Mirror Company, 100 Fifth Avenue, New York, NY 10011

Library of Congress Catalog Card Number 97-73867

ISBN 0-8109-6325-6

Photography, unless otherwise noted, by the Imaging Department, Alan B. Newman, Executive Director

All illustrations are of works by Renoir in The Art Institute of Chicago, unless otherwise noted. Dimensions of works of art are given in centimeters, height preceding width.

Figs. 1, 2, 6, 14, 16: photo © R.M.N. Figs. 3, 23: © Sterling and Francine Clark Art Institute, Williamstown, Mass. Figs. 4, 19: photo courtesy the National Gallery of Canada, Ottawa. Figs. 5, 10: photo © Statens Konstmuseer. Fig. 7: © 1997 Board of Trustees, National Gallery of Art, Washington, D. C. Fig. 8: photo © R.M.N.–Jean Schormans. Fig. 9: All rights reserved, The Metropolitan Museum of Art, New York. Fig. 11: photo © Elke Walford, Hamburg. Fig. 13: photo from Washington, D.C., The Phillips Collection, *The Impressionists on the Seine*, exh. cat. by Eliza E. Rathbone et al., 1996, p. 36. Fig. 18: Courtesy the Trustees of the National Gallery, London. Fig. 21: photo from Ottawa, National Gallery of Canada; The Art Institute of Chicago; and Fort Worth, Kimbell Art Museum, *Renoir's Portraits: Impressions of an Age*, exh. cat. by Colin B. Bailey, 1997, p. 81. Fig. 22: Cliché P. J.–Ville de Nantes–Musée du beaux-arts. Fig. 25: photo © R.M.N.–Gérard Blot. Fig. 26: All rights reserved, © 1997 by The Barnes Foundation. Fig. 27: photo courtesy of Christie's Images, New York. Fig. 29: photo from Lausanne, Musée cantonal des beaux-arts; and Berlin, Georg-Kolbe Museum, *Aristide Maillol*, exh. cat. by Ursel Berger and Jorg Zutter, 1996, p. 151; © 1997 Artists Rights Society (ARS), New York/ADAGP, Paris. Fig. 30: © 1993 Sotheby's, Inc. Fig. 31: photo © R.M.N.; © 1997 Estate of Pablo Picasso/ Artists Rights Society (ARS), New York.

Cover: *Two Sisters (On the Terrace)*, 1881 (pl. 12)
Details: frontispiece (see pl. 4), p.8 (see pl. 2), p. 15 (see pl. 3), p.25 (see pl. 5), p. 33 (see pl. 8), p. 43 (see pl. 12), p. 53 (see pl. 13), p. 63 (see pl. 14), p. 71 (see pl. 18), p. 81 (see pl. 11), p. 108 (see pl. 6)

Contents

Foreword

Pierre Auguste Renoir is one of the best-loved of the French Impressionists. Although his imagery today decorates a seemingly endless variety of candy boxes, posters, scarves, and jewelry, the original works themselves still have the power to enthrall. Standing in front of paintings such as *Two Sisters (On the Terrace)* (pl. 12), we cannot deny the artist's breathtaking mastery of the materials of his craft or the crucial role that he played in the development of modern art.

American collectors first became interested in Renoir's works in the 1880s, largely due to the efforts of the Parisian dealer Paul Durand-Ruel. The Art Institute of Chicago owes many of its finest Renoirs to the generosity of the Potter Palmers and to the Martin A. Ryersons—names that will be familiar to those who attended the museum's 1995 retrospective exhibition *Claude Monet: 1840–1926* as major collectors of that artist's work. When acquiring paintings by Monet, both the Palmers and the Ryersons tended to choose recent works. With Renoir, on the other hand, they preferred his classic Impressionist period, as exemplified in works such as *Lunch at the Restaurant Fournaise* (pl. 2) and *Near the Lake* (pl. 11). In 1892, for example, Bertha Honoré Palmer purchased from Durand-Ruel four important Renoir paintings, all dating from before 1880. When Martin A. Ryerson made his key purchases in the 1910s, he, too, selected works from the 1870s and early 1880s, among them *Woman at the Piano* (pl. 3). This was Mrs. Ryerson's favorite picture, and it hung above her own piano. To the core of Impressionist works by Renoir have been added fine examples from other periods and in various media. In the Art Institute, therefore, we can see Renoir not only as a painter, but also as a draftsman, illustrator, printmaker, and sculptor.

This book—the third in the Art Institute's

series *Artists in Focus*—is published to coincide with the major exhibition *Renoir's Portraits: Impressions of an Age*, and it features five paintings that also appear in the show. This draws our attention to Renoir's ability to transcend the distinctions that separate genres such as portraiture, still life, and landscape.

Douglas W. Druick, Searle Curator of European Painting and Prince Trust Curator of Prints and Drawings at The Art Institute of Chicago, is in a special position to understand Renoir's singularity, both within the museum's collections and in the context of modern art. He has written books and organized major exhibitions devoted to artists such as Edgar Degas, Henri Fantin-Latour, and Odilon Redon, as well as to other aspects of nineteenth-century French art. Using his visual instincts to reveal surprising and delightful elements of the works themselves and his scholarly acumen to situate them in fascinating, shifting historical contexts, Mr. Druick provides us with far more than another set of reproductions of Renoir's artworks —he helps us to participate in the joyous, transfigured world that the artist portrayed.

James N. Wood, Director and President
The Art Institute of Chicago

There are only a very few artists whose work has a powerful and lasting hold on the public imagination. Auguste Renoir is one of them. A painter of real achievement, he created works so appealing that they seem to blur the traditionally held distinctions between "high" art and "low." Long sought after by serious collectors and considered essential to any museums holdings of nineteenth-century French art, Renoir's paintings have, through reproduction, gained currency in the culture at large. Even to those who are largely indifferent to the art of museums, Renoir's canvases recognizably bear its hallmarks.

Why this is so cannot be adequately addressed by reference to the artist's exceptional skills—to the lively color, able draftsmanship, and fluent brushwork that readily demonstrate his impressive mastery of his craft. What ensures their status is the almost transcendent experience

one can have before his best works: in a very particular way, Renoir's paintings seek, often successfully, to transport us out of ourselves and our everyday existence by presenting us with an improved, more brilliant version of life, at once recognizably ours and recognizably different.

Renoir's world—beautiful, harmonious, trouble free—seems in provocative counterpoint to our reality. The artist shows us an earthly paradise that suggests a possible return to the state of innocence personified by the clear-eyed children whom he depicted so intently and affectionately. To yield to Renoir's vision is to look through the rose-tinted glasses, to live *la vie en rose*.

There is a sense of nostalgia associated with the experience of Renoir's art that assumes the form of historical fantasy: we tend to view his paintings as windows into our past, through which we glimpse our culture at a younger,

prettier, and less problematic moment of its development. In other words, Renoir's representations seem to offer us the comfort of "bygone days," of a recent past that appears to us with its edges softened, its forms blurred, but not effaced, by the temporal distance separating it from us.

In a sense, the classic Impressionist technique of flickering brushwork employed by Renoir, Claude Monet, and other members of the group produces a comparable blurring of forms. Yet many of the Impressionists used their unique visual syntax in order to bring into focus some sharp truths. Contemplating their paintings from the perspective of a century, we can all too easily lose sight of the topical, problematic aspects of these representations while engaging only in their remarkable visual effects. Efforts by art historians over the past two decades to contextualize the Impressionist movement have

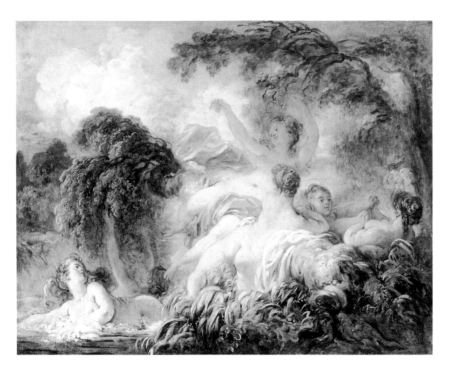

1. Jean Honoré Fragonard (French; 1732–1806). *The Bathers*, 1772/75. Oil on canvas; 64 x 80 cm. Musée du Louvre, Paris.

should be something likeable, joyous, and pretty —yes, pretty. There are enough ugly things in life for us not to add to them." Thus, according to the artist, painting acts not so much as a mirror of life, but as an escape from it.

This credo, which Renoir put into words late in life, guided him throughout his career. His mission was to create a world of perfect beauty and harmony and to provide respite from life as we know it. He recognized the professional dangers inherent in this pursuit. "I realize full well," he observed, "that it is difficult for painting to be accepted as really great painting while remaining joyous. Because Fragonard smiled, people have been quick to say that he is a minor painter. They don't take people who smile seriously." This statement, which invokes the eighteenth-century French painter Renoir had long admired (see fig. 1), reveals his awareness of the particular set of expectations placed on "modern" art and his recognition of his own deviance from them. It also suggests an affective identification between art and artist: joyous painting as an expression of the painter's smile.

Were we to infer Renoir the man from his art, we might imagine a portrait of the artist like the one he painted in the mid-1870s of his friend and fellow Impressionist Alfred Sisley (pl. 1). Sitting casually astride a bamboo-style chair, the handsome and well-groomed Sisley (born in 1839, he

drawn attention to the often burning social and political issues raised in the brilliant scenes of modern urban life painted by Edouard Manet and Edgar Degas, and to detect the disturbing signs of change that subtly intrude upon the sunny landscapes of Monet. Similar tensions almost never lurk beneath the visual surface of Renoir's art. This is not to say that he was insensitive to the problems attendant upon the emergence, during his lifetime, of "modern" French culture or that he was immune to the strains of interpersonal relationships that Degas so brilliantly captured in his work. Rather, Renoir's view of the role of art differed from that of his colleagues. "For me," he insisted, "a picture . . .

was two years Renoir's senior) rests his head on his left hand, his eyes lowered and gently averted. It is a pensive and intimate portrait. Set within a shallow, dark room pierced only by a window at the upper right, the sitter appears close to us, his chair pressed against the plane marking the boundary between the space of the viewer and the fictive space of the painting. Although the composition's dominant tonality is blue, its mood is not one of melancholy; rather, Sisley appears thoughtful and serene, maybe even something of a dreamer. There are no clues to the vocation of the subject, unlike the image Renoir painted of Claude Monet in 1875 (fig. 2), in which the artist holds a palette and brushes. Perhaps Renoir intended his somewhat romantic characterization of Sisley to hint at his profession, as well as to suggest the elegance and gentleness that impressed his friends. Clearly Renoir's representation of Sisley speaks less to shared professional goals than to a friendship linking the two men.

Included in the third Impressionist exhibition, held in 1877, Renoir's portrait of Sisley was praised by one critic, who knew the sitter, for being an "extraordinary likeness and [for its] great value as a work of art." A similar response had greeted the portrait of Monet the previous year, when Renoir exhibited it at the group's second exhibition. There Renoir also showed a

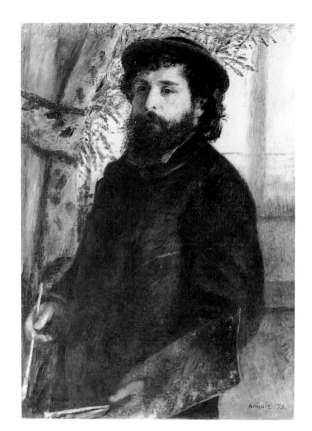

2. *Claude Monet*, 1875. Oil on canvas; 85 x 60.5 cm. Musée d'Orsay, Paris, Bequest of M. and Mme Raymond Koechlin, 1931.

self-portrait (fig. 3), whose veracity is attested by contemporary photographs, but whose psychological expression contrasts sharply with his characterizations of Sisley and Monet. Rather than calm disposition or artistic ambition, Renoir's self-portrait at around age thirty-five exudes restlessness and tension. We recognize the man whose "serious face, . . . furrowed brow, [and] short, rough beard" struck a contemporary, in the 1870s, as making him seem "older than he was." Still others described him as "spare, sharp-eyed, and nervous, . . . incapable of standing still." Renoir was not the individual one might expect from

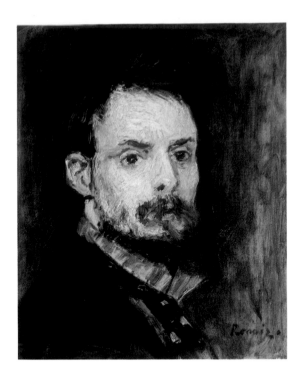

3. *Self-Portrait*,
c.1875. Oil on canvas;
39.1 x 31.7 cm. Sterling
and Francine Clark
Art Institute,
Williamstown, Mass.

Not so Renoir. Born in 1841, the sixth in a family of seven children (two of whom died in infancy), Pierre Auguste was the son of a tailor, Léonard Renoir, and a dressmaker, Marguerite Merlet.

Renoir's native city, Limoges, in south-central France, had long enjoyed a tradition of fine craftsmanship. In the sixteenth and seventeenth centuries, the painted enamelware its craftsmen produced was considered the finest in Europe. Since the second half of the eighteenth century, it owed its prosperity and reputation to the manufacture of hard-paste ("true") porcelain. Its only rival was the porcelain factory at Sèvres, near Paris. Renoir's family moved to the capital when he was three. Ten years later, after attending primary school, he was apprenticed to a porcelain painter whose small firm specialized in copies of Limoges and Sèvres wares. Renoir, who was concurrently taking drawing lessons at a local free school, soon proved his worth, concentrating on decorations depicting the ancien régime's last queen, the ill-fated Marie Antoinette. Surviving pieces of Renoir's painting on porcelain (see fig. 4) attest to his mastery of a Rococo-inspired vocabulary. He nurtured his growing passion for the art of eighteenth-century France with lunchtime visits to the nearby Musée du Louvre, where he added "Fragonard [see fig. l] to my list of favorites, which included Watteau and Boucher, especially his portraits of

looking at his paintings. But the profound connection between this anxious, uncertain man and his art becomes clearer with the recognition that Renoir's pictorial world is a willful construct created in the face of his own experience, quite different from that of Monet, Sisley, and the others with whom he collaborated on the experiment that, in 1874, came to be known as Impressionism.

The Impressionist circle included a number of singular talents who went about realizing in very individual ways their shared ambition of making art modern. But what particularly set Renoir apart from his colleagues was his background. Bazille, Degas, Manet, Monet, and Sisley all came from prosperous, middle-class families.

women." These preferences were not shared by many serious art-lovers at this time. The Rococo style was widely dismissed as superficial and frivolous, if not decadent. Its reputation was further maligned by the enthusiasm for it on the part of the bourgeoisie, whose tastes supported enterprises such as the porcelain factory that employed Renoir. In short, the young artist was developing a special respect for an aesthetic as well as an artisanal tradition that would set him apart from his future Impressionist colleagues.

At the end of his apprenticeship, in 1858, Renoir took a job as a decorator for a manufacturer of "artistic" window blinds. Had it not been for his talent and ambition, he might have remained there. But he sought to further himself, taking advantage of opportunities as they arose. Early in 1860, sponsored by a picture restorer, Renoir secured permission to make copies of paintings in the Louvre. By the end of the following year, he was enrolled in the Paris studio of history painter Charles Gleyre. How this came about is unclear. What is certain is that, in Gleyre, Renoir had found a sympathetic teacher.

The traditionally trained, Swiss-born painter was something of an independent spirit. Neither a member of the French Académie nor on the faculty of the government-sponsored Ecole des beaux-arts, Gleyre distinguished himself as a private teacher from most of his contemporaries

by encouraging individuality. Despite his own preference for figure compositions, he did not thwart student interest in landscape painting and even, during the time Renoir was in his atelier, made studies of the nude out of doors (*en plein air*). Renoir himself would continue to be absorbed by the play of sunlight on the female figure (see pl. 26). Similarly influential was Gleyre's emphasis on the purely technical aspects of painting and his belief that spontaneous execution was dependent on mastery of the brush. This attitude underscored Renoir's esteem for craftsmanship, and it was in these terms that, late in life, he acknowledged his debt to his teacher, noting that "it was under Gleyre that I learned my trade as a painter."

But Gleyre's studio was by no means a trade school, as Renoir must have been acutely aware. Indeed, by enrolling there, and (beginning in the spring of 1862) by simultaneously following drawing courses at the Ecole des beaux-arts, Renoir moved out of the artisanal tradition of apprenticeship into the structured educational system of art school. In deciding to become a painter, as has been noted, he left a vocation and embraced a profession. For someone of Renoir's background, this could be regarded as social advancement. To members of the prosperous bourgeoisie, on the other hand, a similar decision on the part of their sons could raise the specters

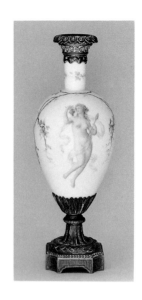

4. *Vase*, 1857.
Oil on bronze-mounted porcelain; h. 29.9 cm.
Private collection.

13

Her performance seems as effortless as her beauty, as if we are witnessing a totally natural extension into the realm of sound of the ravishing visual harmony the player embodies.

of an aspiring artist's uncertain future and questionable, "bohemian" lifestyle; and represented a dangerous rejection of the more certain success promised by careers in medicine, business, or law. In fact, it was sons such as these whom Renoir encountered and befriended at Gleyre's.

Late in 1862, Claude Monet entered the studio, pursuing, at age twenty-two, a commitment to painting in the face of strong parental disapproval. In November, twenty-one-year-old Frédéric Bazille, with three years of medical school behind him, became Gleyre's student with the full moral and financial support of his father, a prosperous agronomist and vine-grower. Shortly thereafter Bazille brought along his friend Alfred Sisley, who, at twenty-three, had abandoned the business career his father had prepared for him and, also without parental opposition, embarked on a career in art. Renoir and the newcomers became friends, and, during the summer months, he worked with fellow students in the forest of Fontainebleau, southeast of Paris.

Renoir became particularly close to Sisley, recalling with pleasure, some thirty years later: "When I was young, I would take my paint box and a shirt, and Sisley and I would leave Fontainebleau, and walk until we reached a village. Sometimes we did not come back until we had run out of money about a week later." These youthful excursions are reflected in *The*

Inn of Mother Antony (fig. 5), the large canvas dated 1866 that is Renoir's first ambitious multifigured composition and a work he would "remember with the greatest pleasure. It is not that I find the painting itself particularly exciting, but it does remind me of good old Mother Antony and her inn in Marlotte. That was a real village inn!"

Marlotte, on the southern edge of the forest of Fontainebleau, was a site of fond memories for Renoir, who frequently stayed in this village during the summer of 1865 and spring of 1866 with Sisley and another friend, Jules Le Coeur, a wealthy architect-turned-painter who had bought a house there. Both men feature in Renoir's composition, set in the inn's dining room: Sisley at the right, sporting an eye-catching hat; Le Coeur, standing behind the table and rolling a cigarette; a third painter friend, opposite Sisley; Mother Antony herself, glimpsed from behind at the far right; her servant Nana, waiting table at left; and her poodle, Toto. At once a group portrait and an image of modern life, the picture's significance in Renoir's oeuvre is greater than his somewhat deprecating fondness for it might suggest. Painted after his entry was refused admission by the jury for the official Salon of 1866, *The Inn of Mother Antony* was conceived in the spirit of an homage to the two controversial leaders of the school of modern painting who likewise in the past had had to endure the Salon

jury's disdain: Gustave Courbet and Edouard Manet. Renoir's picture reveals his debt to the former in its composition, mood, and the monumental scale accorded an inherently modest subject; the example of Manet is evident in the palette of blacks, grays, and brilliant whites, as well as in the notable suppression of halftones.

But Renoir filtered these influences through his own sensibility. The exquisite whites of the starched tablecloth, Nana's creamy apron, and the lustrous dishes lend an aura of genial respectability, which contrasts vividly with the description of the same establishment that the brothers Jules and Edmond de Goncourt had, three years earlier, recorded in their later famous *Journal*. There they described a seedy establishment, its walls covered by graffiti and smears of paint (which Renoir indeed recorded), filled with "wretched painters . . . looking like thuggish workmen" and slatternly, "disreputable" women; a place, in short, where "a rough party goes on day and night with people playing guitars and breaking plates, and with the occasional stabbing."

While these forays into the countryside may have left Sisley momentarily short of cash, Renoir was chronically penniless. His friends did their best to ease his lot. When not in Marlotte, Renoir seems to have stayed in Sisley's Paris apartment, thereby inaugurating a pattern of residency with his more fortunate friends that, over the next few

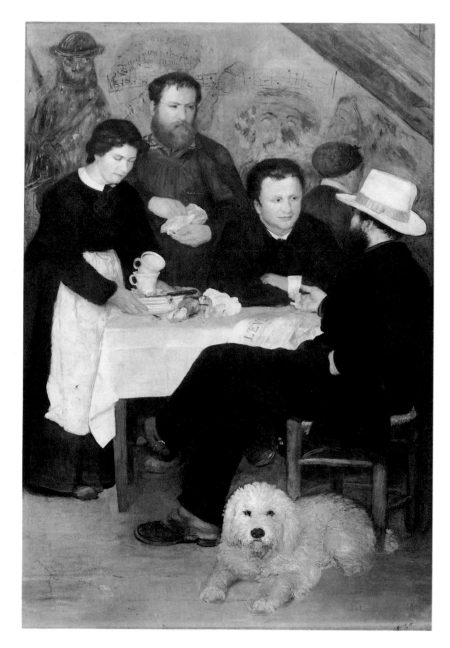

5. *The Inn of Mother Antony*, 1866. Oil on canvas; 194 x 131 cm. Nationalmuseum, Stockholm.

years, would prove not only economical but enriching, as his portrait of Bazille at his easel (fig. 6) suggests. Renoir painted this work in the fall of 1867 in the studio that Bazille had rented

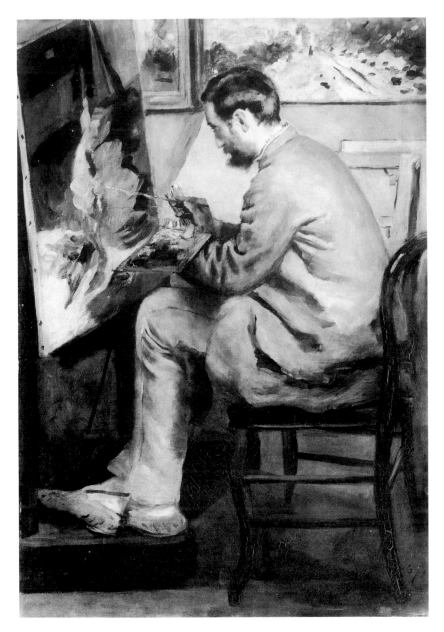

6. *Frédéric Bazille Painting "The Heron,"* 1867. Oil on canvas; 105 x 73.5 cm. Musée d'Orsay, Paris.

of the exact same subject (both works are now in the Musée Fabre, Montpellier), which indicates that Sisley was in the studio painting the same set-up at the same time. The snowscape by Monet hanging above Bazille's head (now in a private collection, New York) alerts us to this artist's presence in the studio earlier in the year, when he had shown up, as Bazille wrote, "out of the blue" and flat broke. A symbol of nurturing friendships and stimulating exchanges of ideas between ambitious young artists, the picture takes on added significance by virtue of its first owner, Edouard Manet, whose style Renoir's painting seems to acknowledge in its elegant economy of means.

Earlier in 1867, Renoir had once again incorporated the lessons of Manet—and Courbet—into his ambitious submission to that year's Salon, the over-life-sized *Diana the Huntress* (fig. 7). Renoir conceived the traditional subject in keeping with the precepts of the groundbreaking Realism both artists practiced, giving the classical goddess of the hunt the unidealized form of his new mistress, Lise Tréhot, and insisting, through his drawing, modeling, and brushwork, on her earthy physicality. Handled differently from the figure, the landscape reads like a backdrop or stage set rather than the natural, sylvan home of the huntress. The attributes she holds fail to convince: seated before us is

one year earlier for himself and, as he explained to his parents, for the "needy painters" he was "lodging." The still life of a heron, in progress on the easel, closely resembles a canvas by Sisley

not a goddess, but rather a contemporary model, posed nude in the artist's studio. This is art announcing its artifice. Unimpressed, the Salon jury rejected Renoir's entry, along with the submissions of Bazille, Monet, and Sisley.

The next year, however, Renoir's fortunes seemed to change. Accepted to the Salon was a life-sized representation of Lise (Museum Folkwang, Essen), fashionably dressed in white, standing and holding a parasol. Emile Zola, the young novelist and art critic who had recently established himself as a spokesperson for avant-garde painting with controversial defenses of both Manet and Monet, commended Renoir's picture as a "truthful . . . exploration of the 'modern,'" recognizing "this *Lise* . . . to be a sister to Claude Monet's *Camille*," a painting (1866; Kunsthalle, Bremen) to which Zola had accorded top honors in his review of the Salon of 1866. Critics now included Renoir, as they had Monet, in the group of young artists who followed Manet's lead.

Renoir and Bazille had in fact literally moved closer to the Manet circle when, early in 1868, they took a studio together in the Batignolles section of Paris, close to the Café Guerbois, meeting place of the group around Manet. One of these artists was Henri Fantin-Latour, who memorialized Manet's leadership in his painting *A Studio in the Batignolles* (1870; Musée d'Orsay,

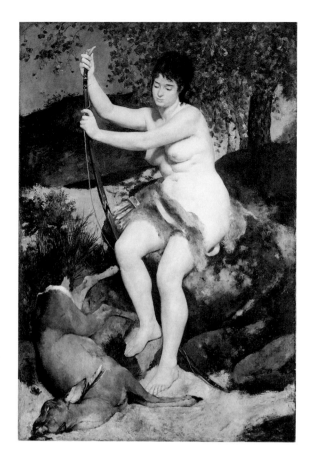

7. *Diana the Huntress*, 1867. Oil on canvas; 199.5 x 129.5 cm. National Gallery of Art, Washington, D.C., Chester Dale Collection.

19

Paris), wherein, around the seated figure of Manet at his easel, he assembled those he considered to be the promising lights of the avant-garde, including Bazille, Monet, Renoir (whom Fantin described as "a painter who will get himself talked about"), Zola, and their friend Edmond Maître, an amateur musician who championed the controversial music of the German composer Richard Wagner. Shortly before Fantin's solemn testimonial was exhibited at the Salon of 1870, Bazille brought together members of this group for a wonderfully informal

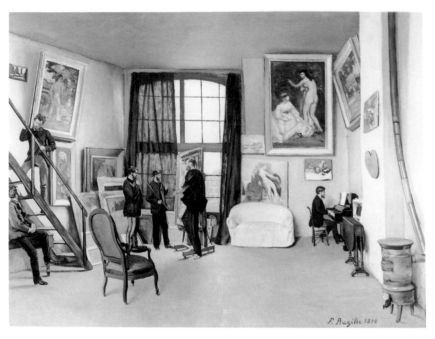

8. Frédéric Bazille
(French; 1841–1870).
*The Studio on the rue
La Condamine,* 1870.
Oil on canvas;
97 x 127 cm. Musée
d'Orsay, Paris.

recasting of the theme (fig. 8). Depicting the new studio he shared with Renoir, Bazille's picture vividly evokes the amicable, creative interaction at which Fantin's picture only hints. According to the traditional reading of the scene, Renoir, perched at the edge of a table at left, looks up to speak with Zola, who leans over the stair railing above him; Bazille stands, palette in hand, beside a work in progress that Manet, with Monet a step behind, appears engaged in critiquing; music is provided by Maître, seated at a piano beneath a large, two-figure composition that Renoir had unsuccessfully submitted to the Salon four years earlier.

In positioning Monet directly behind Manet, Bazille subtly underscored the increasing cen-

trality of Monet to both his own art and that of Renoir. Early in 1869, Monet had worked in this studio, and the following summer Renoir had traveled almost daily to Monet's home near Bougival, west of Paris on the Seine. Side by side, the two painters worked at the nearby boating and bathing resort of La Grenouillère (literally, "The Frog Pond"), recording the same motifs.

Comparison of their paintings featuring the islet and footbridge connecting to La Grenouillère (figs. 9 and 10) reveals Renoir's willingness to submit himself to the authority of Monet's *plein-air* vision, with its lively palette and broken brush strokes. Renoir was playing catch-up, clearly lacking the confidence Monet's assured handling demonstrates. But Renoir's distinct sensibility is also evident. With his crisp brushwork, Monet took care to structure the scene, creating a deep space in which the figures constitute only one texturally differentiated element among several, within a larger whole. Renoir had different interests. Adopting a closer viewpoint, he paid less attention to the task of creating the illusion of depth and more to the costumes and activities of the figures. Painting with free, broad brush strokes and a generally soft touch, Renoir achieved an overall delicacy at the expense of structure.

These qualities would become the hallmarks of his later work. For the moment, however,

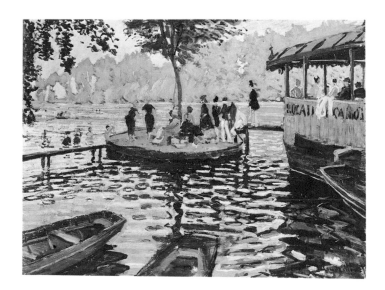

Renoir was content. "We don't eat every day. Yet I am happy in spite of it," he reported, "because, as far as painting is concerned, Monet is good company." He was also a good teacher. By the summer of 1870, Renoir was painting works out of doors that demonstrate an impressive integration of figures and surrounding landscape, as well as an ability to capture the play of natural light on a variety of different surfaces.

France's declaration of war on Prussia on 19 July 1870 abruptly ended the youthful camaraderie Bazille had recorded just months earlier. Bazille, who had enlisted on July 10, was killed in combat in November. Monet escaped the hostilities by fleeing to England with his wife and young child. Sisley, now with two children of his own, remained in France. After losing everything he owned in Bougival because of the war, and

after the death of his father, Sisley found himself without any financial support. Renoir was drafted into the Tenth Cavalry Regiment in late August and was demobilized the following March. He returned briefly to Paris but left again to escape the violent civil strife of the Commune. When he went back in the fall, he found a changed capital, humiliated and subdued by the long siege waged by the Prussian forces, by surrender, and by subsequent internal conflict. But the often-repressive Second Empire of Napoleon III had been brought down. The Third Republic was in its infancy, and a chastened France awaited its future with uncertainty. Renoir, himself relatively unscathed, set about making his way.

The year 1872 began eventfully for the artist: Lise Tréhot, his principal model and companion during the late 1860s, married another man; the

9. Claude Monet (French; 1840–1926). *La Grenouillère*, 1869. Oil on canvas; 74.6 x 99.7 cm. The Metropolitan Museum of Art, New York, The H. O. Havemeyer Collection, Bequest of Mrs. H. O. Havemeyer, 1929.

10. Auguste Renoir. *La Grenouillère*, 1869. Oil on canvas; 66 x 86 cm. Nationalmuseum, Stockholm.

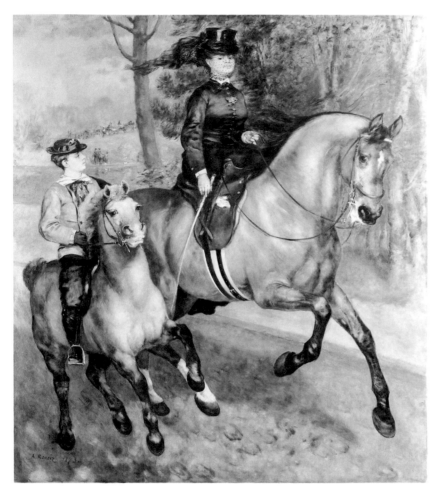

11. *Riding in the Bois de Boulogne*, 1873. Oil on canvas; 261 x 226 cm. Hamburger Kunsthalle, Hamburg.

an exhibition at his London gallery. Nevertheless, it was the official Salon that remained the premier venue for an artist to make his mark; and Renoir, still undeterred by his uneven reception there, now embarked on his most ambitious canvas to date.

Measuring roughly 8½ by 7½ feet, *Riding in the Bois de Boulogne* (fig. 11) seems to have been designed to advertise Renoir's gifts for fashionable portrait painting. Fully participating in the tradition of monumental equestrian portraiture as practiced by such artists of the Baroque era as Antony van Dyck and Diego Velázquez, *Riding in the Bois de Boulogne* makes no attempt to conceal the fact that it is a studio production. Forcefully realized with firm modeling, the horses and riders seem oddly detached from a generalized landscape backdrop. This does not inspire us to imagine the sights and smells of a morning ride in the fresh air, but rather evokes the even light and turpentine scent of the atelier.

Renoir's continued attachment to the conventions of studio painting for his Salon submissions at the same time that he was experimenting with avant-garde, *plein-air* techniques is certainly curious. Unlike Monet, Renoir was seemingly unwilling or unable—perhaps because of ingrained notions of what was expected of a "Salon painter"—to inform his large-scale canvases, consciously conceived for public

Salon jury rejected his latest submission; and Paul Durand-Ruel, the Parisian art dealer who had met Monet two years earlier in London and who would become famous for his allegiance to the Impressionists, purchased two of Renoir's paintings, including a city view. Perhaps spurred by the dealer's interest, Renoir painted *plein-air* land- and cityscapes that are notable for their vivacity and directness. In November Durand-Ruel included the cityscape he had purchased in

presentation, with the techniques he had learned while painting smaller-scale pictures *en plein air*. But to assume that Renoir was simply adopting a conservative stance in order to court approval would be to miss the point. For, in *Riding*, as in his earlier Salon submissions, the painters Renoir referenced most obviously—Courbet and Manet—were artists whose controversial status did not guarantee acceptance by the jury or popular success. Indeed, *Riding* was rejected by the jury for the 1873 Salon.

That year Renoir participated in an official Salon des Refusés (Salon of Rejected Works), organized to appease the artists excluded from the regular Salon. But, as a gesture of conciliation, it was too little too late. Already in April, Monet was discussing with Sisley and Camille Pissarro plans to circumvent officialdom by organizing an independent artists' society. If Renoir was not yet party to these plans, he soon would be.

Renoir spent a good part of the summer of 1873 with the Monet family at Argenteuil. The portraits he painted of Monet's wife, Camille, as well as his celebrated canvas of Monet painting a hedge of multicolored dahlias (fig. 12), attest to a closeness that was not only personal but artistic. With a scintillating surface of small dabs of paint applied with uniform, yet somewhat agitated, brush strokes, Renoir's work is stylistically very

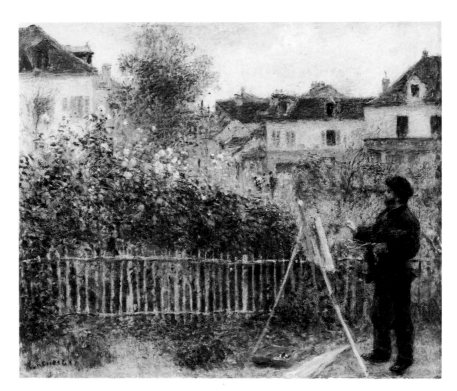

23

12. *Claude Monet Painting in His Garden at Argenteuil*, 1873. Oil on canvas; 46 x 60 cm. Wadsworth Atheneum, Hartford, Conn., Bequest of Anne Parrish Titzell, 1967.

close to that of Monet and speaks to shared ambitions, now focused on plans for an independent artists' exhibition society. In the fall, Renoir returned to Paris. Armed with money gained through the sale of two of his pictures, he rented the apartment and studio on the rue Saint-Georges that would remain his permanent residence until at least 1882. There he hosted several meetings of the future Société anonyme des artistes indépendants, which was officially founded on 27 December 1873. In short, Renoir was settled in and at the heart of things. With the historic events of the coming year, he would truly come into his own.

While a suggestion of their brash behavior remains, Nana and her friends are a sunny vision of fluid grace.

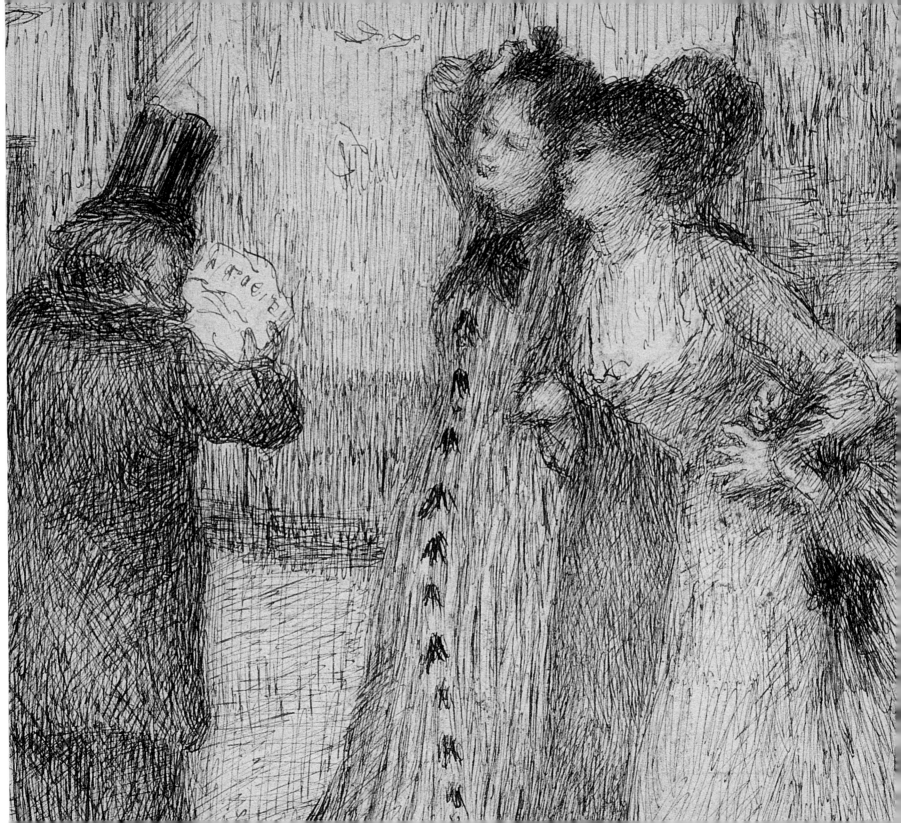

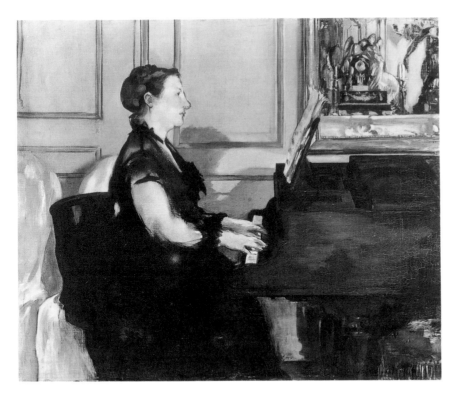

14. Edouard Manet
(French; 1832–1883).
*Mme Manet at the
Piano*, 1868. Oil on
canvas; 38 x 46.5 cm.
Musée d'Orsay, Paris.

Degas, and Manet (see fig. 14) had each treated this theme, but in ways consonant with their pictorial and expressive aims and so quite different from Renoir's. Manet's depiction of his wife, Suzanne Leenhoff, at the piano emphasizes the musical intelligence for which she was admired. The rigorous, planar composition, built on a structure of horizontals and verticals that locks the figure in place, suggests the discipline and concentration she brought to her playing. Rendered in strict profile, Mme Manet is by no means a conventional beauty, but to flatter her as such was not the artist's aim. Rather he presented here a woman of character, an individual whose expression of rapt attention is marked by the tenderness and respect he clearly felt for her.

Renoir's version of a female at the piano is entirely different. The scene takes place in a richly appointed interior with a patterned carpet on the floor; a potted plant placed before a curtain that seemingly marks the opening to an adjoining space; and a picture hung on a fabric-covered wall above a dark, gleaming upright, its top piled casually with music. A remarkably pretty young woman, her luminous, pink hands caressing the bluish-white keyboard, is reading the sheet music open on the stand before her. Her performance seems as effortless as her beauty, as if we are witnessing a totally natural extension into the realm of sound of the ravishing

almost exclusively on *plein-air* landscape painting, Renoir would remain committed to the human figure, especially to representations of women. Moreover, despite the fact that, in the early 1870s, he worked frequently in the country, he remained, unlike his two friends, a visitor there, essentially an artist whose studio and life were in the city. And it his quintessentially Parisian brand of Impressionism that he soon thereafter distilled in *Woman at the Piano* (pl. 3).

This represents Renoir's initial essay at a classic subject, to which he would return frequently in later life. He was not the first of his circle to do so: in the previous decade, Cézanne,

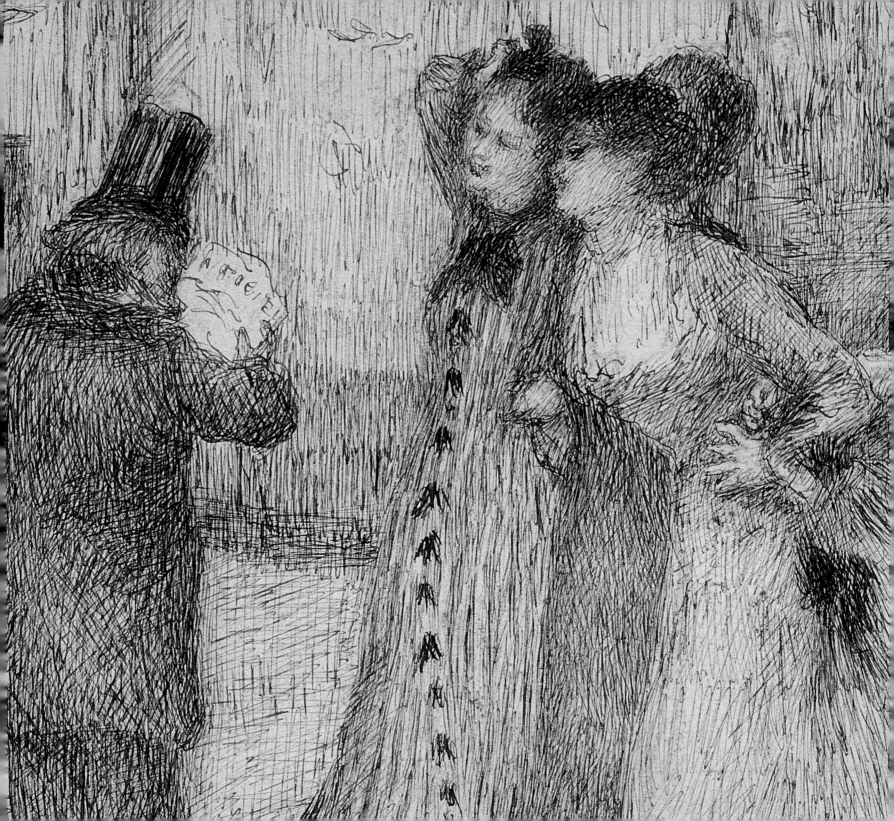

The opening of the first group exhibition of the Société, on 15 April 1874, marked a turning point in French art. Challenging the hegemony of the state-sponsored Salon, this presentation of one hundred sixty-five works, in various media, by thirty artists inaugurated the profound changes in the art market that, by the century's end, would render the Salon obsolete. Moreover, it precipitated the recognition of a new force in art, baptized—ironically, by a less-than-enthusiastic critic—the "Impressionists," after one of Monet's entries, *Impression, Sunrise* (1872; Musée Marmottan, Paris). While the individual styles and aims of the group's true principals—Cézanne, Degas, Monet, Morisot, Pissarro, Renoir, and Sisley—differed considerably, their work seemed in the eyes of hostile critics to be infected by the same "sketchiness" or lack of due "finish" that made Monet's broadly brushed harbor view controversial. At issue was the distinction between the mere "sketch," an idea executed quickly and largely for the artist's own, private purposes, and a proper "picture," the object intended for public viewing, for which the sketches might be preparatory. Such categories of classification belonged to the world of the Salon. But though Renoir had even recently been under their sway, the new opportunity he had helped create set him free, as the six paintings and one pastel he showed brilliantly testified.

These included large, ambitious works that, like *Riding in the Bois de Boulogne*, depict modern women. However, unlike the stolid figures that had populated Renoir's earlier Salon submissions, the females who appear in the works shown in 1874 are elegantly ethereal, their forms fashioned from thin layers of color, brushed in loosely and delicately by an artist now able to achieve his goals with a dazzling, delicate touch. Apparently free from the expectations that had guided his preparations for the Salon, Renoir, seemingly without effort, had made the significant stylistic leap of transposing the techniques of *plein-air* painting to works of greater size and ambition. Despite the controversy that the Société's exhibition inspired, Renoir's unique sensibility was recognized by critics, who praised the "charm," "nervous elegance," and "truthfulness" of his art. One writer predicted: "M. Renoir has a great future." The work the artist produced over the next decade would eloquently bear this out.

The summer of 1875 found Renoir once again on the Seine, west of Paris. This year, however, as if to demonstrate his new independence, he bypassed Argenteuil, stopping at Chatou, near Bougival. There he befriended the Fournaise family, who owned a restaurant, on an island upstream (see fig. 13), that was a well-known meeting place for the oarsmen on the river. Working on one of the terraces of the estab-

lishment, Renoir created a vision of bourgeois leisure that fulfills the promise of the sketch he had painted beside Monet at La Grenouillère six years earlier (fig. 10). *Lunch at the Restaurant Fournaise* (pl. 2) is a paean to the joys of youth and summer; a celebration of the rituals of friendship and bounties of nature, with its seasonal rhythms of rest and play. The three figures around a table include, at left, a young man in a white jacket identified as a M. de Lauradour, habitué of this restaurant and the nearby La Grenouillère; at right, a sunburnt male whose white pants and short-sleeved, collarless shirt, like those of the rowers in the racing boat in the river, seemingly identify him as a boating-club member; and, between them, a young woman seen from the back, her attention engaged perhaps by the man to her left or by the oarswoman near the shore, who is similarly costumed in the blue flannel then favored by female boaters. If the interchange between the figures seems unclear, it is because Renoir avoided making his picture overly legible in narrative terms. Rather than recording a specific interaction, he evoked a mood of conviviality. The fruit, wine, and wineglasses on the table and the way the boater languidly reclines in his chair, casually holding a cigarette, indicate that lunch is over. Pictorially, Renoir's loose brushwork succeeds at banishing narrative specificity and suggests the slightly

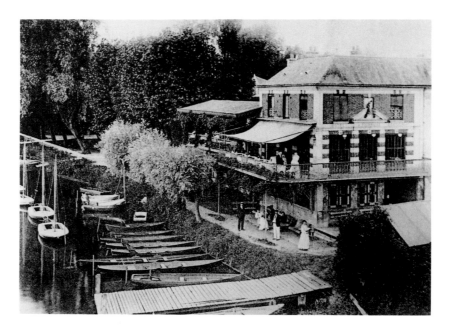

13. The Restaurant Fournaise on the Seine, Chatou, in the 1890s. Les Amis de la Maison Fournaise, Chatou.

fuzzy state of torpor that accompanies satiety. Contours blur, merging one into the other and the surrounding atmosphere, immersing the whole scene in soft and shifting light, with whites tinted by reflections and bluish shadows. The resulting dappled effect is echoed in the stricter rhythms of the trellis, which serves as a permeable barrier between terrace and river.

Suffused with a warmth both social and physical, *Lunch at the Restaurant Fournaise* is a picture of perfect harmony, a vision of a golden age located not in the ancient past but in the present. The focus on people and the lively delicacy with which the softly flickering light is conjured mark Renoir's unique contribution to what we might term "classic" Impressionism. Indeed, while Monet and Sisley concentrated

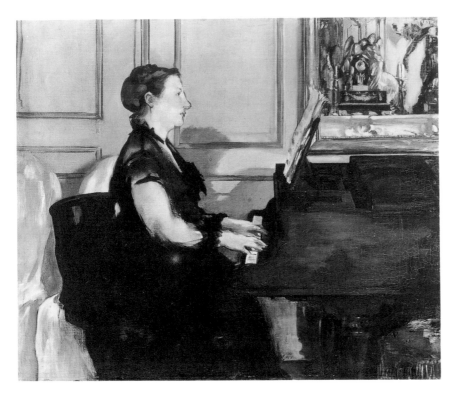

14. Edouard Manet
(French; 1832–1883).
*Mme Manet at the
Piano*, 1868. Oil on
canvas; 38 x 46.5 cm.
Musée d'Orsay, Paris.

Degas, and Manet (see fig. 14) had each treated this theme, but in ways consonant with their pictorial and expressive aims and so quite different from Renoir's. Manet's depiction of his wife, Suzanne Leenhoff, at the piano emphasizes the musical intelligence for which she was admired. The rigorous, planar composition, built on a structure of horizontals and verticals that locks the figure in place, suggests the discipline and concentration she brought to her playing. Rendered in strict profile, Mme Manet is by no means a conventional beauty, but to flatter her as such was not the artist's aim. Rather he presented here a woman of character, an individual whose expression of rapt attention is marked by the tenderness and respect he clearly felt for her.

Renoir's version of a female at the piano is entirely different. The scene takes place in a richly appointed interior with a patterned carpet on the floor; a potted plant placed before a curtain that seemingly marks the opening to an adjoining space; and a picture hung on a fabric-covered wall above a dark, gleaming upright, its top piled casually with music. A remarkably pretty young woman, her luminous, pink hands caressing the bluish-white keyboard, is reading the sheet music open on the stand before her. Her performance seems as effortless as her beauty, as if we are witnessing a totally natural extension into the realm of sound of the ravishing

almost exclusively on *plein-air* landscape painting, Renoir would remain committed to the human figure, especially to representations of women. Moreover, despite the fact that, in the early 1870s, he worked frequently in the country, he remained, unlike his two friends, a visitor there, essentially an artist whose studio and life were in the city. And it his quintessentially Parisian brand of Impressionism that he soon thereafter distilled in *Woman at the Piano* (pl. 3).

This represents Renoir's initial essay at a classic subject, to which he would return frequently in later life. He was not the first of his circle to do so: in the previous decade, Cézanne,

visual harmony the player embodies. Judging from her at-home dress (*robe d'intérieur*), one might assume her to be alone or in the company of an intimate. A confection of white, diaphanous fabric over a bluish underdress, offset by a winding, dark band, it takes on, through the wizardry of Renoir's brush, a life of its own, its brilliant play of chromatic harmonies and counterpoint of sinuous and cascading rhythms providing more than a match for the sounds produced by the piano's black-and-white keys. Designed to conceal, the garment also reveals, as we see from the glints of pink flesh picked out on the young woman's shoulder and arm, by the light that seems to fall softly over her upper body. We witness the scene from a rather odd vantage point: looking down on the pianist from above, a position not only coincident with the painter's but the source as well of the light that pierces the cool darkness of the interior. Yet neither viewer nor painter obstructs the light, casting a shadow. Are we then meant to be looking in through a window? To ask such a question is to take the picture as a representation of fact, when in fact it is fantasy.

As the almost insistently gorgeous color harmonies, based on blue, remind us, Renoir is the artist/performer, the palette is his keyboard, and the woman at the piano is wholly his creation. This is not a portrait of an individual, or even a study of a social type, the skilled bourgeoise; instead it is the depiction of ideal womanhood, uncomplicated by any of the contingencies of the real world. Renoir was in fact uncomfortable with intellectual and educated women, particularly those who nourished professional ambitions. He did not intend, as did Manet, to use the theme of a female pianist to suggest such attributes. His woman at the piano represents the performance of her "natural" function, not the exercise of musical abilities. As Renoir would later write: "In antiquity and among simple peoples, the woman sings and dances. . . . Gracefulness is her domain and even her duty." Eighteenth-century artists might have pictured this ideal as one of the legendary Three Graces, or perhaps as a goddess amid a froth of clouds; Renoir also enveloped his ideal in gossamer, but transported her from the heavens to a piano stool, from the realm of the gods to the modern drawing room.

Georges Rivière, a lifelong friend of the artist, claimed that, for Renoir, to paint a model was to possess her; the painter himself supposedly confirmed this: "It's with my brush that I make love." Deliciously pink, as if cocooned in spun sugar, the woman at the piano is a projection of the artist's desire rather than the representation of its inspiration. Renoir did indeed work from the model, in this case possibly Nini Lopez, a pretty blonde who regularly posed between

1874 and 1880 for other of his contemporary pictures dealing with various aspects of modern life (see pl. 6). Most artists' models came from modest, working-class backgrounds, and assigning them roles, like actresses in a play, was commonplace. But the transformations that Renoir effected with his models seem especially meaningful, for he sought more than beauty in the women who posed for him. The artist considered his relationship to them important: "To get someone to pose," he stated, "you have to be a close friend and above all to know their language." While he made this observation later in Italy, apropos of his frustration at working with models who did not speak French, it has special relevance for his pictures of modern life from the 1870s.

As Rivière would later record, Renoir's models were often "typical of a coarse type of working-class girl," sometimes rowdy and even wild. The artist clearly felt comfortable in the company of young women whose backgrounds were not so far removed from his own, women who "spoke his language." And he seems to have enjoyed transforming these Eliza Doolittles through the language of his art. Rivière recalled one instance of "a beautiful girl whom Renoir accosted one day in the Place Pigalle." Apparently she came from "some seedy house in the Butte Montmartre," and such were her connections in

"the shady world of the outer boulevards" that, whenever she came to the studio to pose for him, Renoir wondered whether he would be robbed. Yet he remade her into a "magnificent figure," an elegant sophisticate in a large-scale decoration he produced in 1876 (today in the State Hermitage Museum, St. Petersburg) for the Paris residence of publishing giant Georges Charpentier. Descending a staircase, she fit as easily into the glittering literary and political salon hosted there by Mme Charpentier as Eliza at the embassy ball. Similarly, it was thanks to the transforming magic of his art that Renoir, the son of a tailor, now found himself included in this elite world.

The Charpentiers acquired one of Renoir's works in 1875. The following year, the artist showed fifteen paintings in the second Impressionist exhibition, including *Woman at the Piano*; *Lunch at the Restaurant Fournaise*; and his portraits of Monet (fig. 2), Bazille (fig. 6), and himself (fig. 3), which constituted public testimony to the significant friendships that had nurtured the development of his personal style. In the catalogue, the Charpentiers' name does not appear among the lenders. It would in 1877, in the catalogue for the third group exhibition , which lists, in addition to Renoir's portrait of Sisley (pl. 1), a portrait of Mme Charpentier and another of her daughter. Also exhibited was his *Portrait of Mme A. D.*—the wife of Alphonse

Daudet—which underscores the importance of the contacts Renoir derived from his growing friendship with the Charpentiers (all three works are now in the Musée d'Orsay, Paris). Daudet was a principal figure in the stable of Realist writers then making Charpentier's fortune. This literary group included as well Flaubert, Edmond de Goncourt, Maupassant, and Renoir's old acquaintance, Zola. Zola, Rivière would recall, was the "man of the hour . . . the author of *L'Assommoir*, a book [published in 1877] whose extraordinary popularity had been unexpected." To capitalize on this success, an illustrated edition of *L'Assommoir* was immediately planned, and Zola asked Renoir to be one of a number of artists to provide illustrations. His response is enormously revealing of how he defined himself as a painter of modern life.

In *L'Assommoir* Zola aimed to depict "morality in action" by producing "the first novel about the common people that does not lie but has the authentic smell of the people." The result was as pungent as it was radically new. Set in a poor district on the northern edge of Paris, it tells the story, to quote Zola, of "the inevitable downfall of a working-class family in the polluted atmosphere of our urban areas." The decline of a laundress, Gervaise, is described as if seen through the eyes of the book's characters, using the crude metaphors and slang of the streets. It is memorable for the picture of brutality and degradation that it so powerfully and relentlessly draws. *L'Assommoir* established Zola's reputation and leadership of the so-called Naturalist school of writing. It was a great success because it was a revelation, shocking the reading public with raw aspects of contemporary life that most regarded with fascination and repulsion.

Renoir did not subscribe to the tenets of Naturalism, with its "scientific" thesis that individual destiny is determined by the interaction of "heredity" (or genetics) and environment, perhaps because the trajectory of his own life suggested otherwise. Later Renoir would say of Guy de Maupassant (whom he met at the Restaurant Fournaise) what he obviously also thought of Zola: "He always looks on the dark side." Maupassant, apropos of Renoir, apparently countered: "He always looks on the bright side." Despite the fact that he was born considerably closer to the experience of poverty than was the author of *L'Assommoir*, Renoir did not see the moral potential of ugliness, preferring to create beauty in its place. His commitment to a visual optimism made the assignment of illustrating Zola's book highly problematic.

In three of the four scenes he depicted, Renoir really could not avoid the seediness and deprivation that constitute the "authentic smell" of Zola's novel; and the results lack conviction,

This is a mood piece, a tone poem in blue-violet suggesting a state of reverie tinted with melancholy.

15. *Father Bru
Stomping in the Snow
to Warm Himself,*
illustration from Emile
Zola's *L'Assommoir*
(Paris,1878), p.194.

as in the scene of Gervaise offering refuge to the penurious Father Bru, "stomping in the snow to try to warm himself" (fig. 15). However, the fourth drawing, *Workers' Daughters on the Boulevard* (pl. 5), is, on several scores, a masterpiece. Renoir selected a memorable scene toward the end of the book, in which Gervaise's daughter, Nana— a voluptuous and high-spirited teenager—makes her first appearance. Zola would later devote an entire novel to Nana's subsequent career as a ruthless courtesan. But in *L'Assommoir* she is

"growing up and becoming quite a piece," precociously deploying her beauty. In this scene, dressed up in all the finery she can muster, Nana, along with her friends, flees her tenement on a Sunday afternoon and heads for the city's outer boulevards:

There all six of them sallied forth arm in arm, taking up the whole width of the pavement, with their revealing frocks and ribbons round their hair. Throwing sidelong glances under their lids, their sharp eyes missed nothing, and they threw back their heads in laughter designed to display the line of the throat. When this noisy, gay crowd collided with a deformed man or an old woman waiting for her dog by the curb, their line would break and one or two fall back while the others fiercely pulled them on; and they swayed their hips, fell on top of each other and flopped about by way of attracting attention, bursting their bodices by displaying their swelling forms. All the street belonged to them, they had grown up in it, lifting their skirts in front of the shops; and now they still lifted them up, but right above the knee to adjust their garters. Amid the slow, dull crowd between the spindly trees, they rushed along. . . . Their flying dresses trailed behind them their youth and innocence, they displayed

themselves for all to see in the glaring light with the coarseness and obscenity of street urchins, provocative and delicious as virgins returning from the bath with their hair still damp.

Zola's word-picture is memorable for its bittersweet complexity. Keenly sensitive to Nana's youthful beauty, he was also aware that her physical blossoming would precipitate the final loss of whatever innocence was still hers: the girl's beauty and ugliness, her potential for virtue and vice are all in the balance. In his interpretation of the scene, Renoir tipped the scale: while a suggestion of their brash behavior remains, Nana and her friends are a sunny vision of fluid grace; Zola's "deformed man," the "dull crowd," and the "spindly trees" have been transformed, as if transplanted from a seedy outer area of the city to its more fashionable downtown. Renoir was no doubt attracted to this scene precisely because it permitted such treatment and struck a chord. After all, to some degree, his models were Nana's sisters, like her a fascinating blend of delicacy and coarseness, at home in the shady world of the outer boulevards. This particular passage also afforded him the opportunity to create a complex, multifigured composition of the sort that he had, for the most part, avoided. The notable exception was the spectacular *Ball at the Moulin de la Galette* (fig. 16), which Renoir had painted in

1876 and exhibited the following year. This breathtaking canvas demonstrates his ability to transpose the spontaneous technique and *plein-air* vision he had perfected in small-scale works such as *Lunch at the Restaurant Fournaise* to compositions on the ambitious scale of those he had previously conceived for the Salon.

The drawing has much in common with *Ball at the Moulin de la Galette*, from the pretty, young girls in their becoming attire and the enveloping atmosphere of flickering light to the vision of glowing youth having healthy, good fun. In fact, the Moulin de la Galette was barely respectable; its clientele included pimps, prostitutes, petty thieves, local toughs, and young artists. That Renoir realized in his drawing something of the atmospheric effects of his painting is a remarkable achievement. In general the Impressionists who painted *en plein air* drew little. This is because their aims were to suggest how light compromises the autonomy of individual forms and to create a whole in which all things and the space that contains them merge in a field of vibrating color. Drawing in monochrome, which requires delimiting forms with linear contours, would seem antithetical to these concerns. Indeed, by the mid-1870s, Renoir had adopted a style that largely replaced drawing with juxtaposed patches of color. But now he found a way to evoke graphically the effects he achieved in his

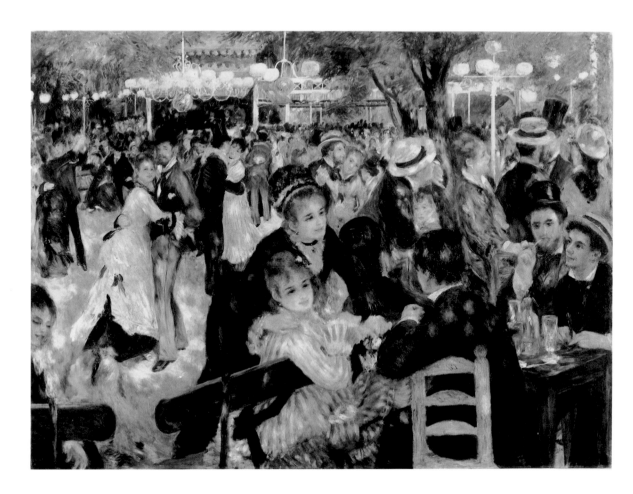

16. *Ball at the Moulin de la Galette,* 1876. Oil on canvas; 131 x 175 cm. Musée d'Orsay, Paris.

painting. Using an ink whose brown tone evokes sunny warmth, Renoir worked with a pen to suggest forms, as well as to lay in areas of shading, with varied networks of fine, scratchy lines, all of which results in a shimmering, active surface. As if eroded by the sun, contours and details seem to blur and dissolve in a wash of scintillating natural light. As ravishing as it is exceptional, *Workers' Daughters on the Boulevard* calls to mind an observation Rivière made about the images of modern life Renoir showed at the 1877 Impressionist exhibition: "We have to go back to Watteau to find [work] with [comparably] pervasive charm."

Renoir's vision of life, like that of the Rococo artist Antoine Watteau, is filtered through a nostalgic longing for a mythic past that lives on in gilded youth and golden sunshine. In Renoir's world, surface is substance, and beauty is never only skin deep; it is a state of grace. This is the magic of his art. For a modern vision tempered by the grit of Zola, we have to turn to the work of another of the artists who frequented the

Charpentier salon: the night-life scenes of Edgar Degas similarly suggest a tainted beauty and capture the heady blend of the attractive and the repellant. The themes of novelist and painter intersect most notably in an attraction to the theme of the laundress, Gervaise's profession, and a subject Degas treated again and again in the 1870s and early 1880s. Inevitably Degas's representations (see fig. 17) stress the back-breaking nature of the work, his figures eloquently conveying the strenuous physical demands and stultifying boredom involved in their unrelenting labor.

When Renoir took up the theme (pl. 6), not long after completing the illustrations for *L'Assommoir*, he characteristically cast it in a more sanguine light. In his painting, the situation is somewhat unclear. Given the suggestion of an elegant, yellow table set in front of a richly patterned background at left, it appears that the setting is the private residence of a client. The ruddy-complexioned young laundress stands, hands on her hips, beside a half-open door. The large washbasket on the floor beside her is filled with unfolded, and therefore probably unwashed, laundry, which the artist's brush has nonetheless rendered white. Although Renoir included signs of her toil—the heavy washbasket and the woman's reddened hands—he did not show her hard at work, like Degas's laundresses. There is

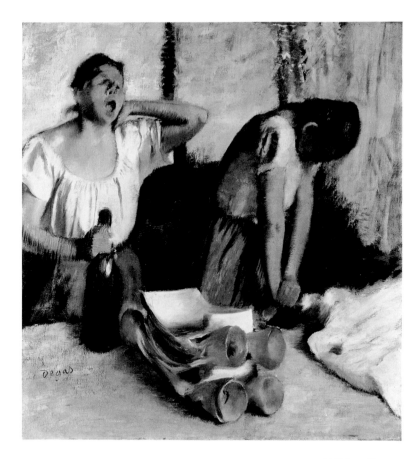

37

therefore no pretext, as in Degas (fig. 17), for her blouse to have provocatively slipped from her shoulder. She glances to the right, apparently engaged by someone or something outside the picture space. And so she is caught unawares, in this moment of apparent repose, in the spectator's gaze. Renoir's audience would have been sensitive to the innuendos in this scene in ways that we cannot be today, since laundresses and working women like them were known to be sexually available—to occasionally supplement their meager incomes with prostitution.

17. Edgar Degas (French; 1834–1917). *Women Ironing*, c. 1884. Oil on canvas; 82.2 x 75.6 cm. Norton Simon Foundation, Pasadena, California.

Zola's Gervaise attempts this near the end of *L'Assommoir*, as she sinks deeper and deeper into poverty. Indeed, one wonders if more can be read into the frank stance and thick waist of the laundress, again modeled on Nini Lopez. But the allusion to social problems would generally not be consistent with Renoir's artistic aims. While he apparently did not exhibit this painting while he owned it (he sold it in 1891), it is not possible to infer anything certain from this. If there are notes of discord, Renoir chose to resolve them chromatically, employing dominant chords of blue and white, accented with yellows and reds.

Renoir's *Laundress* signaled his interest in pursuing the modern-life themes favored by the writers and artists who espoused the Naturalist aesthetic, but also in tempering its cutting edge. This goal is brilliantly achieved in *Acrobats at the Cirque Fernando* of 1879 (pl. 4). The subject was quintessentially of the moment. One of four permanent circuses in Paris, the Cirque Fernando had opened its new, circular, brick-and-iron building in Montmartre in June 1875, attracting an enthusiastic following that included Manet and his friends. It would not be long before the popularity of the entertainment would influence the work of the painters and writers who participated in the Charpentier salon. In March 1879, Charpentier published Edmond de Goncourt's *Frères Zemganno*, a novel

about two brothers who are circus performers. Just two months earlier, Degas had been in the audience of the Cirque Fernando, making sketches for a painting of the gymnast Mlle La La, hanging suspended from the ceiling, a rope clenched between her teeth. About the same time that Degas was working on his composition (fig. 18), Renoir had begun his own Cirque Fernando subject. His canvas features Francisca and Angelina Wartenberg, members of an itinerant German acrobatic troupe, taking their bow and gathering tributes to their just-completed performance: tissue-wrapped oranges, tossed to them by affluent members of the audience, whom we glimpse at the top of the canvas seated ringside in formal attire. Like Degas, Renoir represented his subject close-up, as if seen through opera glasses, in this case from above rather than from below. In part, the foreshortening produced by this viewpoint makes Francisca, who gracefully raises her arms, and Angelina, her arms filled with oranges, appear much smaller and younger than their actual ages—seventeen and fourteen, respectively. The sisters appear more the age we know them to have been in 1879 in a poster produced some years later (fig. 19). But we are also aware today that the strenuous athletic training aspiring gymnasts undergo can slow physical maturation. Close examination of the girls reveals their

bodies to be those of seasoned athletes, with compact torsos held firmly erect and muscular legs sheathed in the pink tights that were part of their working uniform.

Renoir possibly conceived *Acrobats at the Cirque Fernando* for a special event that would underscore his capacities as a painter of modern-life subjects. In April 1879, his patrons the Charpentiers launched *La Vie moderne*, an illustrated periodical whose originality and importance lay in its harnessing of the talent of writers and artists who frequented their salon to the new photomechanical printing technology that would revolutionize journalism. Juxtaposing articles, reviews, and short stories by leading journalists, critics, and writers with drawings by professional illustrators, conservative "modern masters" of the Salon, and such Impressionists as Cassatt, Degas, Monet, Pissarro, and, most notably, Renoir, *La Vie moderne*—as its title unambiguously declares—was devoted to modern life, contemporary art, literature, fashion, politics, and to the goings-on in Paris. It not only recorded but also contributed to the capital's cultural scene: within months of its first issue, the magazine inaugurated a series of exhibitions of works by leading contemporary artists. The show devoted to Renoir, the fifth in the series, opened in June and included pastels and one painting, *Acrobats at the Cirque Fernando*. The exhibition occasioned

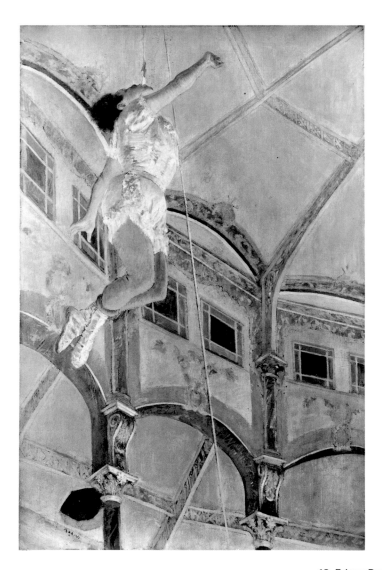

a feature article on Renoir in *La Vie moderne* authored by none other than Edmond Renoir, Auguste's younger brother and a budding journalist. Having identified his brother, as well as himself, as "a collaborator" on the new periodical, Edmond proceeded to review Auguste's career from the early 1860s through *Ball at the*

18. Edgar Degas (French; 1834–1917). *Mlle La La at the Cirque Fernando*, 1879. Oil on canvas; 117 x 77.5 cm. National Gallery, London, Purchased by the Trustees of the Courtauld Fund, 1925.

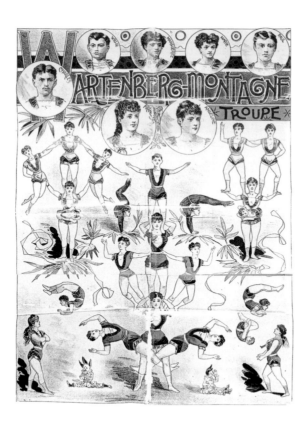

Moulin de la Galette (fig. 16), concluding that, "quite apart from its artistic value, his work has all the *sui generis* charm of a faithful painting of modern life. We see the matter of his paintings every day; it is our own existence that he has recorded, in works that will surely remain among the liveliest and most harmonious of our time." Edmond used *Acrobats* to support his argument:

> In *Acrobats*, there is really no sense of arrangement. He has captured the the two children's movementswith unbelievable subtlety and immediacy. This is exactly how

they walked, bowed, and smiled in the circus ring. I shall not use the grandiose words "Realism" or "Impressionism" to say that what we have here is real life with all its poetry and all its savor. This absence of the "conventional" . . . gives the impression of nature with all its unexpectedness and its intense harmony; it is nature speaking to me.

This characterization, as well as Edmond's insistence that Auguste's art was "innocent" of both "technique" and self-conscious "talent," was a strategy to represent his work as wholly "natural." Clearly Edmond could not have put it forward without the painter's blessing; and yet it was obviously disingenuous. For Renoir's *Acrobats* is nothing if not artful, as comparison with Degas's *Mlle La La* vividly underscores. The rather lurid oranges and greens in Degas's painting capture the harsh effects of the gaslight used during evening performances. Renoir by contrast found such illumination ugly, declaring it to be "an uncertain light that turns faces into grimaces." And so he painted the acrobats as if *en plein air*. Banishing the shadows that read almost like fur on Mlle La La's outstretched arms, Renoir built up his forms with thin, diaphanous washes of color, using delicate, multidirectional brushwork that extends the color of the figures into the space around them and vice versa,

thereby avoiding the sharp distinction in Degas's composition between figure and surround. To increase this visual harmony, Renoir employed a highly arbitrary color scheme that emphasizes chromatic resonance, the yellows and oranges of the circus floor echoing in the girls' costumes as well as in the delicate reflections on the skin tones, most apparent in the area of Angelina's neck. Nor do awkward or unseemly poses, like that of Mlle La La, mar this scene. Renoir captured not the sometimes antic postures of the sisters' act we find in the poster (fig. 19), but rather its aftermath, a moment of almost balletic grace and dignity.

Renoir's painting and his brother's text represent an ideal of modernity that pairs a "lively" sense of immediacy with a respect for the "harmonious." It has been suggested that Renoir, with his brother as his mouthpiece, was claiming for himself the mantle of the alternate Realism that Edmond de Goncourt—like Renoir a passionate devotee of the art of the eighteenth century—had called for in his preface to *Les Frères Zemganno*: that is, a vision of modern life that emphasizes its poetry rather than its sordidness. Indeed, the Renoir brothers' efforts to create a decorous image of the modern painter were to emerge most tellingly in a joint project for *La Vie moderne* undertaken in 1881, when the

two were staying together at a hotel in Menton, on the French Riviera.

There, Edmond wrote a short story, "L'Etiquette," for which Auguste supplied two illustrations. The first (pl. 9), for which Edmond served as model, depicts the opening scene, set in Bordighera, near Menton, on a hotel terrace overlooking the Mediterranean. Jean Martin, a painter from Paris—about thirty, extraordinarily good looking, and fashionably dressed—contemplates his hotel bill. Jean is perplexed by the strange treatment he has been receiving as he moves from hotel to hotel along the coast. The reason, which he will only discover at the story's end, is that he has been mistaken for a prince traveling incognito. As the tale unfolds, his mistaken identity attracts the attention of a wealthy banker, a self-made man anxious to continue his social ascent by arranging a brilliant match for his beautiful, sixteen-year-old daughter, Hélène. The previous year, while on vacation with her mother, Hélène had become attached to a young artist—Jean himself (of course)—whom the banker, receiving the news at home in Paris, immediately deemed unsuitable and had his wife dismiss. Now the banker proposes that the "prince" accompany him and his family on an expedition up the slopes behind Bordighera. Jean accepts, only to find the

Looking at the picture, especially for the first time, is something of a revelation, as if cataracts have been removed and we are able to see the world afresh, recapturing the sense of wonder that we attribute to children.

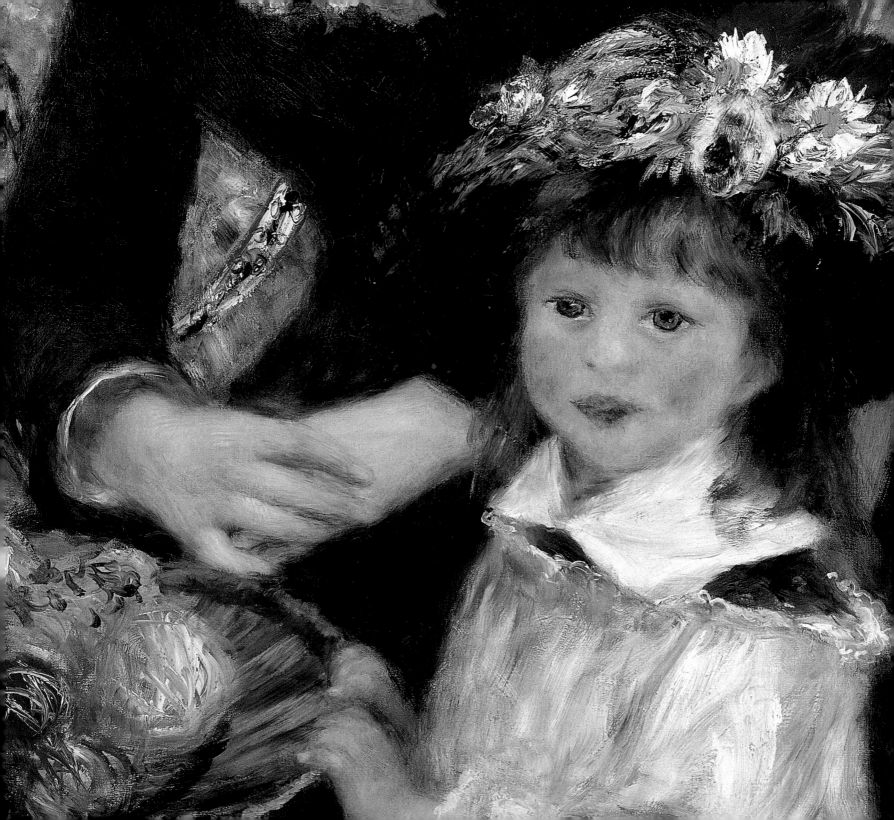

banker's daughter is none other than his beloved Hélène: the man who had separated them has now brought them back together. Renoir depicted the young couple—Hélène elegantly outfitted in "a dress of softly colored Scottish wool and a straw hat" and Jean likewise appropriately attired for the occasion—on their descent (pl. 10). Hélène, about to lose her footing on the steep slope, is steadied by Jean, affording them a rapturous opportunity for decorous physical contact. The story proceeds to the inevitable dénouement, which is wholly unremarkable as literature but fascinating for the insight it provides into the aspirations of the Renoir brothers. The banker, at first chagrined to discover that Jean is not a prince but rather a painter, ultimately concludes that he is a prince among painters. Not only is he handsome, well-mannered, and duly respectful of paternal authority, but—as Jean proudly attests—he is successful, earning some twenty thousand francs a year. It is the banker himself, however, who identifies the true measure of the young man's worth, when he ostentatiously declares to his wife and daughter that he knows Jean to be "a painter of talent, for I have seen more than one important canvas by him at the Salon."

Though written in 1881 and published in 1883, "L'Etiquette" speaks to a strategy involving the Salon that Renoir had adopted in 1879. Not only did he identify himself with the particular cosmopolitan spirit that was the essence of *La Vie moderne*, but he also followed the advice of its publishers, the Charpentiers, who counseled him to return to the official Salon in order to establish the credentials necessary in the fashionable world in which Mme Charpentier was now his unofficial chaperon. And so it was that Renoir— along with Cézanne and Sisley—declined to participate in the fourth Impressionist exhibition, which opened in March 1879, electing instead to submit works to the Salon jury. While the work of his two colleagues was rejected, Renoir's dazzling group portrait *Mme Charpentier and Her Children* (1878; The Metropolitan Museum of Art, New York) was accepted and well placed in the Salon galleries. Critics welcomed Renoir's return "to the bosom of the Church" and hailed his gifts as a colorist. His gambit had paid off: he had, at least within the limited but highly influential circle of the Charpentiers, made his reputation.

While it is easy to see this as a defection or failure of courage, we should consider the circumstances. As Camille Pissarro observed to a friend: "Renoir has been a great success at the Salon. I think he has made his mark. So much the better; poverty is so hard." Indeed, the next year, a financially strapped Monet would follow Renoir's lead, abstaining from the fifth Impressionist exhibition in order to try his

fortunes at the Salon. But money was not the only issue. Monet, we must remember, continued to subscribe to the view that, for a young painter, "the Salon is the real field of battle." And indeed Zola recognized both factors when he later defended Renoir's decision:

> M. Renoir was the first [of the Impressionists] to understand that commissions would not come his way by those means [independent exhibitions]. Since he needed to earn a livelihood, he started again to send paintings to the official Salon, which led to him being treated as a renegade. I am a defender of independence in all things; however, I confess that the conduct of M. Renoir appears to me to be perfectly reasonable. One must recognize the admirable means of publicity that the official Salon affords young painters; in the current climate, it is uniquely there that they may achieve serious recognition. Certainly one must keep one's independence in the work itself, one must waste nothing of his temperament, and then one must go into battle in full sunlight.

The climate had indeed changed for Renoir. While he would never possess the suavity of the fictional Jean Martin (to the contrary, he would continue to astonish some of his well-bred acquaintances with his manifest lack of social graces), Renoir, now something of a "court painter" to the Charpentiers, extended his reach. Following his success at the 1879 Salon, he spent most of the summer at the vacation estate of Paul Antoine Berard at Wargemont, near Dieppe on the Normandy coast. Renoir had met the diplomat and company director, who was from a family of Protestant bankers, at the Charpentier salon, and from 1879 onward the Berards would be central to Renoir's career. Like the Charpentiers, this successful, rich bourgeois family was sufficiently without affectation to accept Renoir as he was: a gifted painter whose manners lacked the delicacy he so deftly displayed in his paintings. In residence, as it were, between July and September, Renoir executed a series of individual portraits of Mme Berard and her children, as well as decorations for the château: still lifes of the fall and summer hunts for the dining room, and of flowers for both the library and drawing room. Still-life and figure painting come together in *Young Woman Sewing* (pl. 7), probably one of a number of non-commissioned canvases Renoir produced at Wargemont in the course of his stay.

The flowers—apparently asters and chrysanthemums—suggest that Renoir executed the composition in late summer. His decision to depict the young woman up close and slightly from above, as if she were unaware of his proximity, results in a particular sense of informality

and ease that the social distance between the painter and the members of the Berard family would not allow. In fact, however, this is not a portrait but a genre scene; the unidentified young woman—simply dressed but wearing jewelry—assumes the role of model rather than sitter. Giving almost equal visual emphasis to the floral still life and the woman, Renoir joined two representational traditions, establishing a type of equivalence between the transient beauty of flowers in bloom and that of the young female in her physical prime. Thus the artist expressed his unquestioning belief in the traditional gender distinctions that identified woman with "nature" and man with "culture." The young woman's activity underscores this identity. She is engaged in the virtuous pastime of needlework. It seems she is, in fact, embroidering, adding colors to the white material she holds in her hands. Her creative efforts offer parallels to those of the painter, who applies color to white, prepared canvas; yet her work, unlike his, is confined to the domestic sphere. It was here, Renoir believed, that women found their true role. "I love women," he would later tell his son Jean. "They doubt nothing. With them the world becomes very simple. They give everything its correct value and realize full well that their laundry is as important as the constitution of the German empire. Near them one feels reassured."

Renoir's equivalence of the feminine and the natural informed his vision of nature itself, as is evident in *Seascape* (pl. 8), one of at least three *plein-air* subjects executed while at Wargemont in 1879. Here Renoir depicted a site untouched by urbanization or modernization. In focusing almost exclusively on the sea and sky of the Normandy coast, admitting only a glimpse of shoreline at the lower right, he was reprising, certainly consciously, a subject and compositional treatment Courbet pioneered in a series of works initiated in the mid-1860s. But Renoir purposefully transformed the meaning of the theme of breaking waves viewed from a beach. Courbet, both in his bold handling and use of cold, glassy greens, had insisted on the sheer power of the sea, creating a chilling spectacle of an untameable, elemental force. Renoir, by contrast, working in a gamut of violets deployed with his characteristic delicacy and lightness of touch, constructed a more "feminized" picture of nature, frothier and less foreboding, even though a storm appears to be rolling in. In his treatment of the waves, we detect the same decorative intent visible earlier in the cascading gown that is the focus of *Woman at the Piano* (pl. 3). Unlike Monet, who would travel to the Normandy coast and paint the exact same theme the following summer, Renoir was less attentive to the colors of nature than to his intuitive

response to the scene before him. The chromatic harmonies he invoked do not so much suggest temperature as reveal temperament; here the Impressionist proclaims his affinity with the Romantics and their subjective response to nature. This is a mood piece, a tone poem in blue-violet suggesting a state of reverie tinted with melancholy. It is a play on the emotional resonance of the color blue, later to be exploited by the young Pablo Picasso and reflected in the French language in the expression "n'y voir que du bleu"—literally, "to see only blue"—which means to be puzzled ("all at sea") or to remain blissfully unaware of something. Suggestively contradictory, these meanings would in fact soon characterize Renoir's state of mind and, in turn, his art.

In the fall of 1879, Renoir returned to Chatou and there revisited earlier themes of recreation and leisure. Possibly it was at this time that he painted *Near the Lake* (pl. 11), the canvas whose title (which it has carried since at least 1887) makes it difficult to specify its subject and date. There is no record of Renoir's having visited a body of water other than the Seine or the Atlantic during the years to which, stylistically, this painting must be dated. Are we, in fact, looking at a bend in the river Seine; or did the painter visit a site such as Lac Enghien, a popular vacation spot fifty minutes by train from Paris via Argenteuil? Whatever the circumstances of its creation, Renoir here represented a youngish man casually leaning on a balustrade, cigarette in hand, engaged in conversation with a girl depicted in profile, her eyes hidden by the wide brim of a flower-bedecked straw hat. *Near the Lake* echoes the Art Institute's earlier boating subject (pl. 2) and, like it, can be seen to anticipate the ambitious work that Renoir would begin in the summer of 1880, when, following a second stay at Wargemont, he would write to Paul Berard: "I am at Chatou. . . . I'm doing a painting of oarsmen which I've been itching to do for a long time." The result was Renoir's masterpiece, *Luncheon of the Boating Party* (fig. 20).

In *Near the Lake*, we see two figural types Renoir would recast in his large, multifigured composition of the following summer. The man in the Chicago painting wears the banded straw hat of the boater, as well as the casual jacket and blue, collarless shirt that complete the costume. His companion's pose, as well as her hat, invite comparison with the woman at the left of the large canvas. The model for this figure was Aline Charigot, the twenty-one-year-old seamstress who would soon be the artist's mistress and eventually his wife.

Although there is an obvious thematic continuity from *Lunch at the Restaurant Fournaise* (pl. 2) through *Near the Lake* (pl. 11) to *Luncheon*

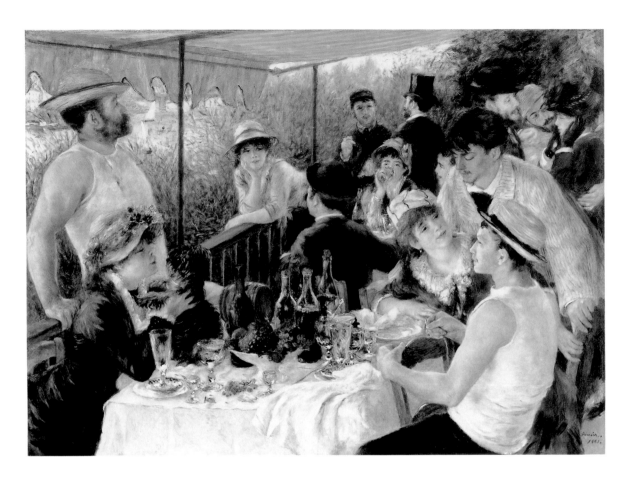

20. *Luncheon of the Boating Party*, 1880–81. Oil on canvas; 129.5 x 172.7 cm. The Phillips Collection, Washington, D. C.

of the Boating Party (fig. 20), the three works represent different points in the evolution of Renoir's style. We have only to compare *Near the Lake* with *Lunch at the Restaurant Fournaise* to recognize differences between the two in both touch and palette. Instead of the freely brushed surface and unified atmosphere of the earlier work, Renoir now employed a more varied brushwork to differentiate the components of the scene: for example, he used longer, horizontal strokes for the water; shorter and more vertical strokes for the water; shorter and more vertical

ones for the hanging vines; and still thinner and shorter hatching marks for parts of the clothing. Though the artist again suggested the effects of outdoor sunlight, entering obliquely below the scalloped awning that protects the terrace, he made less of an attempt to absorb everything into an overriding harmony of colored light. Rather, the play of tinted reflections seems confined to individual forms, and the palette itself is more saturated with deeper accents, as in the rich, dark blue of the boater's shirt.

In *Luncheon of the Boating Party*, Renoir pushed these stylistic investigations still further, on the monumental scale of *Ball at the Moulin de la Galette* (fig. 16). With its crisply delineated forms, the painting marked an important shift in Renoir's style. This shift would be crystallized in a picture that Renoir would paint at Chatou the following spring, a memorable work that would bring down the curtain on his remarkable series of paintings dealing with the theme of Parisians relaxing in the country: *Two Sisters (On the Terrace)* (pl. 12).

The ambition and appearance of *Luncheon of the Boating Party* have been explained variously. On the one hand, the painting can be seen as an outgrowth of Renoir's recent experience with portrait commissions, which forced him to render his figures more precisely, as individuals. On the other, it can be interpreted as the artist's response to the challenge Zola made to the Impressionists in his review of the 1880 Salon: that rather than being satisfied with sketchy, small-scale works done quickly, they should essay ambitious and considered canvases of important, modern-life subjects. But *Luncheon of the Boating Party* also reveals Renoir's current dissatisfaction with his art. Indeed, as Zola's article hinted, the shared sense of purpose of the original Impressionist group had begun to unravel. The fifth group exhibition, held in 1880, took place

without the participation of Cézanne, Monet, Morisot, Renoir, and Sisley. While Morisot returned for the sixth exhibition, which opened in the spring of 1881, Gustave Caillebotte now joined the apostates. Although the politics of group dynamics played a part in these abstentions, the overriding question, expressed more in actions than words, was: "Where do we go from here?"

Renoir found himself at a turning point. His life was changing, and his art with it. The dealer Durand-Ruel, whom Renoir had known for nearly a decade, purchased *Luncheon of the Boating Party* in February 1881, inaugurating a steady pattern of acquisitions that, along with portrait commissions, left Renoir with greater financial independence than he had ever known. He was becoming restless, and now he had the means to give his restlessness active expression. He began to widen his horizons through travel. Around the end of February 1881, he went with his brother to Algeria, stopping in the south of France, where they collaborated on the story for *La Vie moderne*. But it was less the issues of modern life and more the painting methods of the Old Masters that now preoccupied Renoir. In the minds of many in the art world, Algeria was associated with Eugène Delacroix, due to the Romantic painter's visits to North Africa earlier in the century. Renoir's responses to what Edmond called the "intense

picturesqueness" of this region were conditioned by his admiration for Delacroix's mastery of color. As Edmond would recall: "The Mediterranean proved irresistibly seductive to [Auguste's] astonished eyes, more accustomed to the pale lights of [Paris] and its surroundings." But if the Algerian sun elicited a new luminosity in Renoir's palette, it was his work at Chatou that had prepared him for it; and there, on a terrace of the Restaurant Fournaise, he would continue its exploration in *Two Sisters (On the Terrace)* (pl. 12), following his return to France in early April.

The painting, one of the most celebrated in Renoir's oeuvre, was under way by April 19, when, at lunch in Chatou with the expatriate American painter James McNeill Whistler, he shared his reason for postponing a planned trip to London: "I am engaged in a struggle with trees in bloom and women and children and can see no further than that at the moment. . . . The weather is fine and I have my models; that's my only excuse." In point of fact, close study of the painting and of X-rays, which can sometimes reveal the artist's changes of mind that lie hidden beneath the final paint layer, reveals little in the way of struggle. Rather, the picture is a technical and compositional tour de force, in which Renoir displayed his virtuosity by marrying his newly vibrant palette with his newly variegated brush-

work. It is a celebration of the promise of beauty that is both spring and youth.

Situated on yet another terrace of the Restaurant Fournaise, the two figures—they were not, in fact, sisters but rather unrelated models— occupy a shallow space that is a provocative extension of the space of the viewer. The table supporting the pannier of brightly colored yarn inhabits a zone that both figures and spectator share. And yet, the "sisters" seem oblivious of artist and viewer standing directly before and above them; otherwise distracted, their glances follow their interests in different directions. This allows us the freedom to stare, to take in the beauty of the scene without the risk of having our gaze returned. And Renoir insured that the figures hold our attention. The foliage and river view behind them, freely painted using varie- gated brushwork, is softer in focus and chromati- cally more muted than the young woman wearing the female boater's blue flannel and the little girl in white beside her. Tightly delineated, the figures are visually captivating. Renoir, displaying extraordinary refinement in blending the contin- uous tones that build up the faces, endowed each with a delicate porcelain complexion. This is set off by a brightly colored hat, enhanced, especially in the case of the child, by vivid decorations of flowers executed in rich, luxuriant impasto.

The effect of the intense, saturated blues, reds, and pinks is not, as it would have been in earlier work, compromised by colored reflections; the latter, like shadows, have been largely banished. The result is an almost startling luminosity.

Looking at the picture, especially for the first time, is something of a revelation, as if cataracts have been removed and we are able to see the world afresh, recapturing the sense of wonder that we attribute to children. Indeed, as has been observed, Renoir's fascination with childhood led him, in his paintings of children, to attempt "to recreate his idea of the child's immediate response to visual experience, unconditioned by the knowledge of good and evil." He achieved this here by endowing the wide-eyed little girl with irises of an almost startlingly clear, translucent blue. On the other hand, those of her sloe-eyed, older companion are notably darker, less penetrable, and more knowing. These distinctions, as well as the contrasts in color and value of the costumes, the number of flowers decorating the hats, and the evident (though undisclosed) differences between what attracts their attention suggest successive moments in the evolution from innocence to experience, from a state of nature to one in society. Possibly it was this sense of the stages of growth or development that prompted Durand-Ruel, who purchased the

picture from Renoir in July 1881, to give it the title *Two Sisters*. And perhaps it was the combination of picture and title that led some reviewers to detect something indecorous about the canvas. One described the older "sister"—the model for whom was eighteen-year-old Jeanne Darlaud, a budding actress whose modest theatrical career would, so to speak, be upstaged by a more successful one as the companion of rich men— as a "modern Mona Lisa who knows all about love and seduction and is shamelessly flirting with you."

But in fact it was the painter who deserved the charge of "sly" behavior. For, in a sense, the painting is a celebration of art. The natural foliage behind the figures is no rival for the vivid artificial flowers that luxuriantly adorn the hat of the little girl. Moreover, the balls of colored yarn, somewhat inexplicable given the outdoor setting and clear references to warm-weather boating, seem, as has recently been suggested, to constitute "a self-referential metaphor for Renoir's own vibrant palette and astonishing virtuosity." Symbolizing the raw materials out of which are fabricated the products that can rival nature, the balls of yarn may refer to Renoir's own craft as a painter, providing him with the opportunity to display his calligraphic brushwork and gifts for vivid chromatic accents. Indeed, as early as 1879 and into

[Renoir] deliberately weighed the relative placement [of the fruits and vegetables], as if the surface on which they rest were not a table but some form of see-saw that could be tilted by the slightest miscalculation.

the 1880s, his technique was sometimes referred to by skeptical critics in terms of "knitting," his pictures described as being "constructed of different colored balls of wool."

But if the presence of the balls of yarn was deliberately ironic, the picture's inclusion in the seventh Impressionist exhibition, held the year following its completion, was not. Renoir had not participated in the Impressionist exhibitions of 1879, 1880, and 1881, and he had no intention of doing so in 1882. But Durand-Ruel organized this show, and, going against Renoir's wishes, he included twenty-five of the artist's paintings then in his possession, including *Luncheon of the Boating Party* and *Two Sisters*, works that announced Renoir's departure from "classic" Impressionism's preoccupation with rendering transient effects of light by means of flickering brushwork. In the meantime, Renoir had already moved further beyond Impressionism's concerns and practices.

At the end of October 1881, Renoir left for Italy. In part his motivation was to address the lingering discomfort he felt in the upper-class circles that had become the source of his portrait commissions. A trip to Italy, as he informed Mme Charpentier, made it possible for him, when quizzed in polite conversation about his artistic education, to "reply bluntly, 'Yes, sir, I have seen the Raphaels.'" But if Renoir regarded Italy as a

kind of finishing school, it was also his art that he hoped to refine. He felt a bit "at sea" as to the direction he should take; he was in a period of transition and realized that there were relevant lessons to be learned in Italy. In retrospect, the artist would view this trip as a turning point in his development. But clearly he left with an idea of what he hoped to find: exemplars of a quality that was already emergent in his art, the reconciliation of the contingent with the permanent.

Fruits of the Midi (pl. 13), a still life of fruit and vegetables, speaks to this concern. Peppers, eggplants, tomatoes, pomegranates, citrons, lemons, and oranges are piled together on a blue-and-white plate or disposed on a white cloth nuanced with pinks and blues. It is not clear exactly when and where this picture was painted. Citrus fruit is harvested in the spring, and pomegranates in late summer. In late August or early September, Renoir was once again with the Berards at Wargemont. But the title, which has accompanied the painting since at least 1908, specifies southern France, implying that Renoir may have painted it on the way to Venice, where he arrived on 1 November 1881. Yet the picture most closely related to this one, a smaller still life of onions (Sterling and Francine Clark Art Institute, Williamstown, Mass.), was executed in Naples later that same year.

Whether painted before departing for, en

route to, or actually in Italy, this still life carries further the experimentation with intense local color and crisply defined form evident in *Two Sisters*. Dealing with an arrangement of inanimate objects, Renoir was freer to concentrate on formal exploration than he had been with figural subjects. *Fruits of the Midi* is remarkable for its carefully balanced composition and for the sense of solidity and integrity with which the artist endowed each of the two dozen richly colored and attentively modeled objects. He deliberately weighed their relative placement, as if the surface on which they rest were not a table but some form of see-saw that could be tilted by the slightest miscalculation. There is an austerity here that is new in the art of Renoir, signaled by the relative plainness of both tablecloth and background, constructed with longish, diagonal brush strokes. These are repeated in the fruit, contributing to the almost classical sense of calm and monumentality that Renoir clearly hoped to achieve in this luminous canvas. The still life thus anticipates, or possibly reflects, his response to the art that made the greatest impact on him during his Italian trip. In Rome, he was struck by Raphael's ability to create monumental forms without sacrificing luminosity. "Although Raphael never worked outside," Renoir observed, "he did study sunlight, as his frescoes are full of it." Similarly in Naples he admired the "grandeur

and simplicity" of the Pompeian frescoes on view in the national museum.

To achieve luminosity while respecting the integrity of forms, to apply the lessons of Impressionism in the service of an art that retains a classical sense of pictorial structure, balance, and monumentality—this was the project that Cézanne too was currently pursuing, working with quiet persistence in and around Aix-en-Provence. As early as 1877, Renoir's friend Rivière had described Cézanne as "a Greek from the great period; his canvases have the calm, the heroic serenity of antique paintings." Renoir, who had made a pastel portrait of the Provençal artist in 1880 (private collection, New York), would later echo this assessment in terms of his own enthusiasm for ancient art: "There is something [in Cézanne's work] that is similar to the things from Pompeii—so rough and admirable." *Fruits of the Midi* seems so close in spirit to still lifes by Cézanne that, at one time, it was mistakenly thought to have been painted by Renoir under his direct influence. What happened, in fact, was that the qualities in the art of Raphael and of Pompeii that Renoir admired and that he expressed in this still life led him to Cézanne, whom he visited in L'Estaque, on the Mediterranean coast just west of Marseille, in January 1882, en route from Italy to Paris. A decade earlier, Renoir had learned, at Monet's

side, how to capture transient light effects by painting *en plein air*. Now, working with Cézanne under the brilliant, southern sun, Renoir sought to master the lessons suggested by Raphael's frescoes. He painted in a "perpetual sunlight" whose constancy, as he wrote to Mme Charpentier, imposed fewer time constraints than the ever-changing sunlight of Paris, affording him the chance "to efface [my picture] and begin over again as often as I wish. That [process] is the great teacher." Studying nature in the harsh, nearly vertical sunlight of the Mediterranean region, Renoir felt that he was learning to see differently, to recognize, as he put it, the "broad harmonies without bothering . . . with the small details." In effect, he was learning to see like Cézanne, Raphael, and the ancients.

For Renoir the excursion to Italy marked the beginning of years of constant experimentation, with his time in Paris punctuated at first by frequent trips. In the spring of 1882, he returned to Algeria, on his doctor's advice, following a bout of pneumonia. Planning to stay two weeks, he remained six. But of necessity his artistic quest had to accommodate portrait commissions, which remained for him an important source of revenue. At the beginning of the summer, Renoir accepted a commission from Léon Clapisson, whom he had met at the Charpentier salon, to paint his attractive wife, Valentine. While the source of

Clapisson's fortune remains something of a mystery, it was no secret that he had recently begun collecting the work of the Impressionists, including several of the Algerian paintings that Renoir had just deposited with Durand-Ruel. Perhaps this is the reason that the artist decided to paint Mme Clapisson *en plein air*, taking tea in the rose garden. The sessions did not go well. Although the "exquisite" Valentine was a compliant sitter, Renoir complained of having difficulty completing the "wretched portrait, which will not work." And when, after many sessions and much frustration, he finally finished it (fig. 21), M. Clapisson found it "too audacious." He returned the picture to the painter, who agreed to undertake a more acceptable likeness. Renoir was discouraged by what he called his "big flop" and declined Berard's invitation to Wargemont in October, explaining his anxiety that his reputation among his patrons might slip (*plein-air* portraits he had just completed of Durand-Ruel's children had also not been well received). He added, "I've been away a little too much. I must withdraw a little into my shell."

It was around this time that Renoir may well have painted a glorious still life, *Chrysanthemums* (pl. 14). While Renoir had recently produced a number of elaborate flower pieces (sensitive, as was Monet, to the market potential of such works), this painting, featuring flowers in a

simple, brown, earthenware kitchen crock set on a floral-patterned tablecloth, seems to have been more of a personal exercise. Renoir would later say, "I just let my brain rest when I paint flowers. I don't experience the same tension as I do when confronted by the model. When I am painting flowers, I establish the tones, I study the values carefully without worrying about losing the picture. I don't dare do this with a figure piece for fear of ruining it. The experience I gain from these works, I eventually apply to my [figure] paintings." Despite the creative freedoms allowed by the genre of still life, *Chrysanthemums* nonetheless reveals Renoir's continual need for technical exploration. Possibly executed with the roses in the foreground of the failed Clapisson portrait (fig. 21) in mind, *Chrysanthemums* explores very different territory than did *Fruits of the Midi* and reminds us that Renoir's experimentation during the 1880s led him in different directions, often simultaneously. Here the problem Renoir set himself did not involve issues of weight, balance, and monumentality, but rather transparency and luminosity. Taking a canvas with a white, commercially prepared ground, he used a palette knife to lay in another ground of lead white paint. Although this second layer was thick and took time to dry, it offered particular advantages. Obscuring the grain of the canvas, it resulted in a surface that was much

21. *Among the Roses (Mme Clapisson)*, 1882. Oil on canvas; 100.3 x 81 cm. Private collection.

57

smoother and more capable of reflecting light than a canvas that had not been prepared in this way. Exploiting this to the maximum, Renoir worked very quickly, building up the image with freely applied, thin layers of washlike paint. The remarkable transparency achieved by means of this technique invites comparison with water-color—a medium yet to attract Renoir's attention —as well as with the art of overglaze porcelain painting. The artist's early grounding in this craft must have helped to fuel experimentation at a time when, once again, he was seeking his way.

Begun in 1882, Renoir's second portrait of Mme Clapisson (pl. 15) is executed very

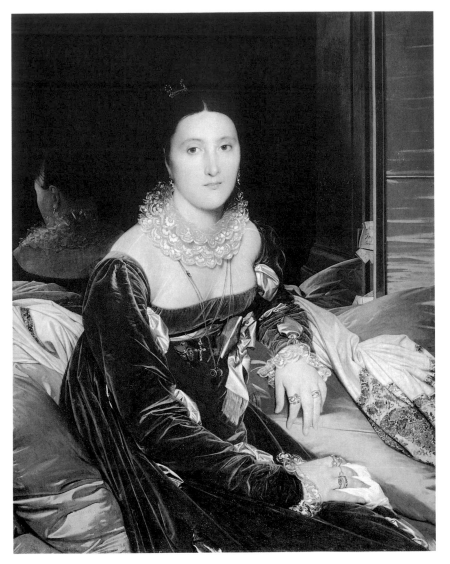

22. J. A. D. Ingres
(French; 1841–1919).
Mme de Senonnes,
1814–16. Oil on canvas;
106 x 84 cm. Musée
des beaux–arts,
Nantes.

pages of *La Vie moderne*, it was tailored to satisfy the Clapissons' needs. Yet Renoir's recipe here is not that of the conventional society portraitist of the time. Although he had jokingly informed Berard that he intended to swear off doing "portraits in the sunlight" and instead to adopt the plain, dark backgrounds then in vogue, Renoir in fact set his sitter before a light-filled, abstract design in which he wove together the red, yellow, and blue that he employed with greater concentration in the chair, gloves, and dress. And while the pose of Mme Clapisson echoes that found in contemporary society portraiture, it makes more specific reference to the great French Neoclassical painter J. A. D. Ingres. When in Rome, Renoir had conceded the brilliance of Raphael's frescoes, but also maintained that, "for oil painting, I prefer Ingres." His favorite work by Ingres—the "magnificent" portrait he deemed the artist's "masterpiece"—was *Mme de Senonnes* (fig. 22). The general pose, tilt of the head, and angle of the shoulders, as well as the taut contours in *Mme Clapisson* reveal that Renoir was thinking about Ingres as he created an image that has been aptly described as a "remarkable synthesis of the conventions of Neo-Classical portraiture with a colourist palette."

differently, using less diluted, stiffer paint. Representing Valentine indoors, in an evening dress that shows off her shoulders and arms, this portrait found favor with his clients. A fashionable image of a woman sufficiently *à la mode* to have had her white sauce discussed in the society

Such a recognition of his ambitions might well have pleased Renoir, as, indeed, this portrait

pleased the Clapissons. But when he sent the painting to the Salon of 1883—it was his only submission—he was disappointed by the lack of critical response. He was, as Berard confided to a friend, "utterly discouraged." He would only submit to the Salon one more time, in 1890. In the spring of 1883, Durand-Ruel held a retrospective exhibition of seventy of Renoir's works at his gallery. In the preface to the catalogue, Théodore Duret, a leading critic and longtime supporter of the Impressionists, observed: "I regard M. Claude Monet as the Impressionist group's most typical landscape painter and M. Renoir as its most typical figure painter." But, in fact, it no longer made sense to call Renoir a "typical" Impressionist. He had, for all intents and purposes, abandoned the quintessential Impressionist vision exemplified in the light-eroded forms and colored atmosphere of *Lunch at the Restaurant Fournaise* (pl. 2). Increasingly, as *Mme Clapisson* seemed to proclaim, his way of seeing things was shaped by the authority of line. But this was not a strict progression, as his next portrait—that of Lucie Berard (pl. 16)—would reveal.

By the summer of 1883, Renoir had produced a number of likenesses of the four Berard children. The youngest, Lucie, had thus far figured only in a single canvas, an intimate "study

23. *Studies of the Berard Children*, 1881. Oil on canvas; 62.6 x 82 cm. Sterling and Francine Clark Art Institute, Williamstown, Mass.

sheet" in oils featuring all of the children (fig. 23), which Renoir had painted in the summer of 1881. Lucie, then just one year old, is represented both asleep (at upper left) and awake, a picture of alertness (second from upper right). Now three, Lucie remains the personification of attentive innocence; dressed in white, with her small, soft hands positioned rather helplessly at her sides and her clear, blue eyes unclouded, she looks out past the viewer, as if toward her future. Once again Renoir apparently fashioned a portrait that suited his sitter, but this time it was his own vision that dictated its form. For, while in conception and handling *Lucie Berard* recalls *Mme Clapisson*, Renoir's treatment here is softer.

Setting the little girl against a background of violet blues with touches of yellow that envelops her white smock, Renoir treated his subject with a delicacy that preserves her tentativeness.

So consistently touching is Renoir's picture of childhood that sometimes, embarrassed by what seems to be an unabashed appeal to sentiment, we take the artist to task. We are wrong to do so, because Renoir was not conforming to a stereotypical representation of youth, but recasting it in his own personal terms. At the time that they were painted, *Lucie Berard* and portraits like it were criticized not because they pleased too much, but too little. In a letter written just months after his daughter's portrait was completed, Paul Berard left no doubt on this score: "I've gone to the expense of having a beautiful frame made for the portrait of Lucie, which I've hung in the best spot in my study, and Marguerite and I swoon with pleasure in front of it; but, unfortunately for Renoir, we cannot get others to derive the pleasure that we do from his work, and this portrait, so different from the type that [is currently fashionable], simply frightens people away." Over the next few years, Renoir's aggressive pursuit of his "new manner"—the linear, or "Ingriste," style that informs *Mme Clapisson*—continued to frighten off potential patrons, to such an extent that by the mid-1880s portraiture had ceased to be a major source of his income.

The decisive shift in Renoir's style, which had clearly been in the making for several years, is usually pinpointed to 1884. In December 1883, he had traveled with Monet along the Mediterranean coast. Monet's enthusiasm for this region led him to return for several months. In response, Renoir resolved to stay in Paris; for he was, as he told Monet, a "figure painter" and did not need to travel to find the "perfect model." In fact Renoir was experiencing a crisis. As he later explained to the dealer Ambroise Vollard, he felt that "he had reached the end of Impressionism, and had come to the conclusion that he could neither paint nor draw." He embarked on a particularly intense period of experimentation, during which he traveled little, focusing on the problems at hand, problems worked on—and, eventually, worked out—in the large painting that was three years in the making: *The Great Bathers* (fig. 24), which he would exhibit in 1887.

Renoir had never been in the habit of executing preparatory studies, even for a large, complex painting such as *Luncheon of the Boating Party* (fig. 20). Now, for the first and only time in his career, he immersed himself in a process in which drawing played a central role. In a sense, he was putting himself back in school, and he brought an intense focus to his self-imposed task, as exemplified in a sheet of studies of trees

24. *The Great Bathers,*
1884–87. Oil on canvas;
117.7 x 170.8 cm.
Philadelphia Museum
of Art, Mr. and Mrs.
Carroll S. Tyson, Jr.,
Collection.

and foliage in The Art Institute of Chicago (pl. 18). He used pen and ink for all but one of these studies, which are so finely detailed and sharply observed that they resemble lacework. Some are developed further with vibrant suggestions of color. And indeed the largest of the three studies on the right—an exquisite treatment of foliage in pure watercolor—reveals that Renoir's new linear concerns did not displace his long-standing preoccupation with color.

Among the most remarkable works from this period are his drawings of the figure, as Berthe Morisot recognized when she visited Renoir's

studio in 1886 and reported on the progress of his new style:

> Visit to Renoir's studio. On an easel, a drawing in sanguine and white chalk [see pl. 17] . . . charming grace and finesse. As I admired it, he showed me a series . . . more or less in the same spirit. He is a draftsman of first-rate powers; all his preparatory studies for a painting would be curious to show to the public who generally imagine that the Impressionists work only in the most free and easy manner. I think that one cannot go further in the rendering of form; two

Renoir worked very quickly, building up the image with freely applied, thin layers of washlike paint.

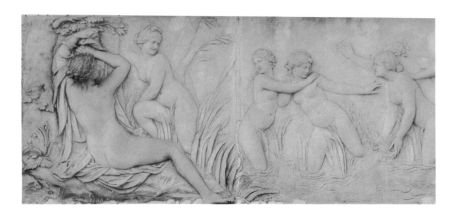

too achieved a shallow but insistently sculptural modeling. He would ultimately apply this approach to the forms of his large painting.

This is what bothered Pissarro when, in 1887, he saw *The Great Bathers*, on exhibit for the first time. "I do understand what he is trying to do," he wrote to his son. "It is not proper to want to stand still, but he chose to concentrate on line, [and] his figures are all separate entities." Indeed, the figures in Renoir's monumental composition are all independently conceived, and their disconnectedness is more striking than their interaction. This feeling is reinforced by the differences in focus between the sharply observed figures and the soft, imprecise landscape setting, which they clearly do not inhabit. The result is something of a collage, not unlike the artist's studio pictures (see fig. 11) before his discovery of Impressionism.

The shift marked by *The Great Bathers* and related works from the period is not simply stylistic; it is ideological. In the same way that Renoir divorced his figures from the landscape surround, so too he removed himself from the contemporary life that he had celebrated—albeit selectively—in his greatest works to date. These bathers are not shop-girls going for a dip in the Seine. Inexorably linked, through their sources, to the art of the past, they inhabit no specific

drawings of naked women . . . charmed me to the same degree as those of Ingres. He [Renoir] tells me that the nude seems to him one of the indispensable forms of art.

The extraordinary *Splashing Figure (Study for "The Great Bathers")* (pl. 17; see also fig. 24) bears out the astuteness of Morisot's observations. Defined by taut yet supple contours, the figure combines a linear rigor with powerful modeling and remarkable luminosity: Renoir brilliantly conveyed both the firmness of the model's youthful form and the iridescence of her water-drenched, sunbathed skin. The classical lineage of this drawing can be traced back through Ingres to Raphael, with an intermediate stop at Versailles, locus of much of the eighteenth-century art Renoir so admired. For the figure derives from a low relief by François Girardon in the park of the palace (fig. 25). By endowing his *Splashing Figure* with an aura of white, Renoir

place or moment. Rather, as underscored by the painting's subtitle (*An Experiment in Decorative Painting*), it is clear that Renoir had in mind the example of the extravagant figural fantasies of Fragonard (see fig. 1) and the grand fresco decorations of Raphael. With *The Great Bathers*, Renoir attempted to create a timeless art for all time.

Renoir's withdrawal from modern subject matter has traditionally been linked to changes in his personal life—notably, the birth of his first son, Pierre, in 1885, which solidified his long-term relationship with Aline Charigot—as well as to his artistic experimentation. But Renoir was by no means the only major painter who, in the mid-1880s, was wrestling with technical problems, rethinking Impressionism, and seeking a new path. We have seen how Cézanne was attempting to, as he later put it, "[make] out of Impressionism something solid and durable, like the art of museums." Degas too was seeking greater monumentality and simplicity in his work, focusing on the theme of the nude. The younger Georges Seurat mounted a frontal attack on Impressionism in 1886, with the monumental canvas *A Sunday on La Grande Jatte* (The Art Institute of Chicago), painted in a radically new technique and shown at the last Impressionist exhibition (which Renoir once again boycotted).

26. Georges Seurat (French; 1859–1897). *The Models*, 1886–88. Oil on canvas; 200 x 248 cm. Barnes Foundation, Merion, Penn.

The year after Renoir showed his *Bathers*, Seurat exhibited his own major statement on the subject of the nude (fig. 26), a work that Renoir professed to loathe. But if Renoir's rethinking was part of a larger phenomenon in avant-garde painting, we must recognize that neither Degas nor Seurat felt the need to abandon the theme of contemporary life to fulfill their new ambitions. Renoir did so because the permanence he sought could not be achieved solely through stylistic means.

The classic Impressionist manner, with its emphasis on capturing fugitive effects of light and movement, seemed perfectly matched to a

dynamic, bustling, ever-changing "modernity." Renoir's pictures of contemporary life, such as *Ball at the Moulin de la Galette* (fig. 16), focused on its excitement, promise, and beauty. Above all, as we have seen, he represented *la vie moderne* as harmonious and carefree, undisturbed by conflicts of class, gender, and race or by the larger social dilemmas that followed the rapid industrialization launched under Napoleon III. As economic and cultural modernization continued, however, bringing with it such sweeping changes as rampant urbanism, industrial capitalism, and the collapse of traditional social values, Renoir found it increasingly difficult to look upon contemporary subjects with his former optimism. As recent scholars have convincingly argued, he coped with this situation by making a series of "withdrawals": first, in the late 1870s, from Paris to the pleasure spots along the Seine; and then, in the early 1880s, from all sites of modern life into an imagery of an unchanging Nature. And while the French countryside, hardly immune to the effects of industrialization, was currently in the throes of an agricultural depression, Renoir nonetheless created images that speak of constancy, of an idealized, inviolable relationship between the people and the land. He evolved his anti-Impressionist technique in the service of what could be called anti-Impressionist subject matter. His paintings

spoke to a fear of modernity and, as such, they were expressive of growing anxiety in France on this score.

Renoir's linear style found little favor with his fellow painters, his dealer, or potential patrons, as the epithets commonly applied to it —"acrid," "sour," or "harsh"—suggest. In the absence of commissions and with new responsibilities on the domestic front, Renoir now brought his portraiture home. For the rest of his career, with some notable exceptions, his sitters would be members of his family. In the mid-1880s, Aline Charigot assumed the place in Renoir's portraits that had, until very recently, been occupied by the fashionable habitués of the Charpentier salon. In *Maternity* (fig. 27), she is pictured nursing her firstborn, Pierre, and it is significant that the artist chose to represent the wholesome Aline unself-consciously engaged in the nurturing that a Mme Berard would doubtless have delegated to a wet-nurse. He made studies in preparation for *Maternity*, and then repeated the composition in two subsequent versions. *Studies of Pierre Renoir; His Mother, Aline Charigot; Nudes; and Landscape* (pl. 19), a canvas of sketches in which Aline is seen at the right, wearing a hat, and young Pierre along the left, both awake and asleep, was painted during this campaign. The other studies that fill the canvas—of nudes and landscape motifs—

underscore Renoir's associations of the theme of maternity with the fecundity of nature, as well as his belief that providing nurture to the child and the man is woman's legitimate role. This was a subject about which he would become increasingly strident with the emergence of feminisim and the so-called "new woman."

Once again, however, Renoir's representation is highly selective, a picture of his life as though it were free from the social constrictions he obviously continued to feel. As a painter, he remained confident of his work; when Morisot visited his studio in January 1886, Renoir happily showed her several of the studies for *Maternity*. But he remained less than confident about his social position. It was not until 1891 that he would introduce Morisot to Aline, his companion of more than a decade. Strangely, it seems that Renoir was conditioned by respect for notions of propriety; just as he had adhered to artistic traditions in his early Salon submissions, so he was apparently guided by certain conventions in his social behavior. He finally married Aline in 1890, legally recognizing their long-standing union and their five-year-old son. Only thereafter, it seems, did Renoir feel comfortable bringing into the upper-middle-class, cultured society of Morisot and her friends the woman of such a different stamp whom he had chosen as his partner.

27. *Maternity*, 1886.
Oil on canvas;
73.7 x 53.3 cm.
Christie's, New York.

The Art Institute's *Studies* exhibits none of the tight linearity that characterizes Renoir's treatment of the figures in the finished painting, *Maternity*. Rather, Renoir used diluted oil paints almost like watercolor and the prepared, white

canvas like a sheet of paper, developing both figures and landscape with limpid washes of transparent color while leaving areas of the support untouched. The placement of the various forms on the canvas also recalls drawing methods, especially those of Watteau, who would artfully distribute different studies across the surface of a single sheet of paper.

In this intimate, private painting, Renoir relaxed the discipline that currently guided him in realizing his large-scale, "public" statements. The work points to a direction that Renoir's art would subsequently take, as does *Grove of Trees* (pl. 20), a study executed in watercolor a few years later. Here Renoir's lightness of touch complements the gentle rhythm established by the repeated tree trunks and the cursive strokes indicating grasses in the foreground, resulting in a work of great refinement that, once again, evokes the spirit of the eighteenth century. This is a site that Watteau's elegant pleasure seekers might well have chosen for their aristocratic revelries. As such, *Grove of Trees* also signals a critical moment in Renoir's career. The color of the leaves indicates that the season was autumn; quite possibly he drew it in the fall of 1888, while he was staying in Aline's home village of Essoyes, and when he came to an important decision. In September he discussed his current

situation with Pissarro, informing him, as Pissarro related to his son, "that everyone, from Durand-Ruel to his old collectors, is criticizing [Renoir] and attacking his attempts to break with his romantic period." Probably not long thereafter, Renoir wrote several letters from Essoyes to Durand-Ruel, describing the manner he was now pursuing as "very soft and colored, but luminous," and vowing: "I have taken up again, never to abandon it, my old style, soft and light of touch . . . but with a small difference. . . . It's nothing new, but rather a follow-up to the artists of the eighteenth century . . . (like Fragonard, only not so good)."

The year 1888 thus marked the end of a difficult period for Renoir, and the beginning of a decade characterized by renewed expansiveness and success. Renoir began to travel again, visiting sites in France and also journeying abroad to see the great museums in Madrid (1892), Dresden (1896), Amsterdam (1898), and, at some point during these years, London. Similarly, when in Paris, he spent a lot of time in the Louvre. For like his former colleague Degas, Renoir had the Old Masters very much in mind during the 1890s. While he shared Degas's reverence for the great practitioners of the classical tradition of line, notably Mantegna and Poussin, he was now more focused on the masters of color and broad

handling—Rembrandt, Rubens, Titian, and Velázquez—and, as he had declared, on the art of the eighteenth century in particular.

Although Renoir's style had changed, his goals had not: he remained committed to creating an art that celebrates timeless values, as the dialogue he engaged in with artists of the past expressed. The increasingly rhythmic, cursive brushwork found in *Grove of Trees* recurs in paintings of the 1890s and has been linked specifically to the example of Fragonard (see fig. 1). Renoir's passion for the eighteenth century is also reflected in the new importance he gave to the theme of the young child, especially after the birth of his second son, Jean, in 1894. *Jean Renoir Sewing* (pl. 21) is one in a long sequence of pictures in which Renoir explored the theme of youth as innocence. These were works in which he took considerable personal satisfaction. "One must be personally involved in what one does," Renoir wrote to a friend when Jean was just seventeen months old. "At the moment, I'm painting Jean pouting. It's no easy thing, but it's such a lovely subject, and I assure you that I'm working for myself and myself alone." Jean later recalled, "When I was still very young—say at the age of three, four, or five—instead of deciding on the pose I was to take, [my father] would wait until I found something

to occupy me and keep me quiet." Although Jean claimed to "remember quite clearly all the preparations for the picture now in The Art Institute of Chicago, showing me sewing," and maintained that he was over five years old at the time, other, dated pictures suggest that *Jean Renoir Sewing* actually portrays him a year or so younger. But it is also true that the length of his hair is of little help in dating these works. For while long tresses were in fashion for infant boys, Jean, to his great embarrassment, was forced to wear his hair this way for an unusually long time —until the autumn of 1901, when, at age seven, he went to a school whose regulations required it be cut. Renoir's love of the "pure gold" of Jean's silken hair, as well as his desire to preserve this attribute of innocence in his paintings of his son, overrode any concern for the relentless taunts that Jean had to endure from other boys.

None of the "coarse" and "heavy" qualities that Jean would remember preferring in his clothing as "a reaction against this unfortunate hair style" offset the delicacy of *Jean Renoir Sewing*, which is characteristic of Renoir's paintings of the late 1890s. The range of colors is simple, indicative of the artist's desire to limit his means in his ongoing obsession with mastering his craft, and the restricted palette somewhat muted. The chromatic intensity, as well as the

*[Renoir] used pen and ink for
. . . these studies, which are so finely
detailed and sharply observed
that they resemble lacework.*

variegated brushwork, that characterizes *Two Sisters* (pl. 12) has been replaced here by a unified, softly luminous, and thinly painted surface. Moreover the modeling has become more traditional than it was in Renoir's earlier work, reliant on gradations of the same tone rather than on contrasts of warm and cool colors.

Durand-Ruel was pleased with Renoir's work of this period. Thanks to the dealer's renewed efforts on the artist's behalf, the circle of buyers of his art—both early and current—widened to include new collectors. Among these was Mrs. Potter Palmer of Chicago, who, in the spring of 1892, began to acquire what would be an extraordinary group of works by Renoir from Durand-Ruel's Paris and New York galleries (see pls. 2, 4, 8, 11, and 18). The same year, the French government bestowed its official approval on the artist when it purchased for the Musée du Luxembourg, the Paris museum devoted to contemporary French art, one of his recent canvases, *Young Girls at the Piano*. This theme is recurrent in Renoir's art of the period, but even more often he chose as his subject young women wearing modern costumes, especially the fancy hats then fashionable. While the artist intimated that such works were concessions to an enthusiastic market, apparently he enjoyed their making. *Two Sisters* attests to his earlier attraction to vivid hats as decorative foils for youthful

beauty. Moreover the hats he now featured in his work appealed to him less, it seems, as signs of contemporaneity and more because they evoked the sumptuous fashions of the eighteenth century. Berthe Morisot's daughter, Julie Manet, would record in her diary on 8 January 1898: "I went to see M. Renoir in his studio. He's been doing more things than ever this winter and showed me a ravishing portrait of an actress . . . wearing a Directoire period costume with roses and a huge gray hat. . . . He thought my hat was very pretty, which pleased me as I never buy a hat without wondering whether M. Renoir will like it."

In 1894, the year before Morisot died of a pulmonary infection, Renoir depicted Julie, wearing one of the hats she so enjoyed, in a double portrait with her mother (now in a private collection). Renoir had become very close to Morisot over the previous decade, having decided that she was exceptional, since "any other woman with all of [her talents] would manage to be quite insufferable." Indeed he, along with Degas, had been part of the family council set up in 1892, following the death of Morisot's husband, to administer Julie's affairs. Now the poet Stéphane Mallarmé was appointed Julie's guardian, and she was sent to live with cousins who were also orphans. In the summer following Morisot's death, Renoir and his wife

practically adopted Julie, who, with her cousins, vacationed with the Renoirs in Brittany. They joined the Renoirs again during the summer of 1897, this time in Essoyes, and once more briefly the following summer. During one of these stays, Renoir made a pastel of Julie and her cousin Paule Gobillard (current location unknown), which served as the model for the color lithograph *Pinning the Hat* (pl. 22).

The subject of *Pinning the Hat* speaks to Renoir's attachment to the past; at the decade's end, Durand-Ruel tried, without success, to dissuade the artist from such themes, because elaborate hats had gone out of fashion. But the medium of the work—color lithography—was very much of the moment and points to a new influence in Renoir's life, the young dealer and publisher Ambroise Vollard (see pl. 24). Born on the island of La Réunion in 1867, Vollard went to France in 1890 to study law and, about three years later, opened a small picture gallery on the rue Laffitte in Paris. Sensing the revival of interest in lithography on the part of young artists such as Henri de Toulouse-Lautrec and aware that a buying public was eager for original works of art at affordable prices, Vollard enlisted both established and emerging talents in the service of his publishing ambitions, issuing portfolios of color lithographs by Pierre Bonnard and Edouard Vuillard, as well as albums of prints

in lithography and other media by a variety of contemporary artists. Renoir contributed a drypoint to the first of these albums, published in 1896. But soon, like his old friends Cézanne and Sisley, he was persuaded by Vollard to try his hand at lithography, working with the publisher's brilliant printer, Auguste Clot. *Pinning the Hat* was one of the results of this collaboration, which yielded more than twenty lithographs in black and white as well as in color.

Renoir and Vollard apparently first met in the fall of 1895, just months before the opening at Vollard's gallery of the first important exhibition ever held of Cézanne's paintings and drawings. Their shared admiration for Cézanne's art—it was the 1895 exhibition that prompted Renoir to compare his work with Pompeian paintings—would find expression in the lithographic version (pl. 23) that Renoir would make for Vollard after his 1880 pastel portrait of Cézanne. But shared admirations and printmaking aside, Vollard would play an important role in the final evolution of Renoir's art as he moved into the twentieth century.

Toward the end of the 1890s, the course of Renoir's life—and art—once again began to change. In 1898 he had purchased a house in Essoyes, his first truly permanent residence, where his youngest son, Claude, was born in 1901. However, Renoir suffered increasing

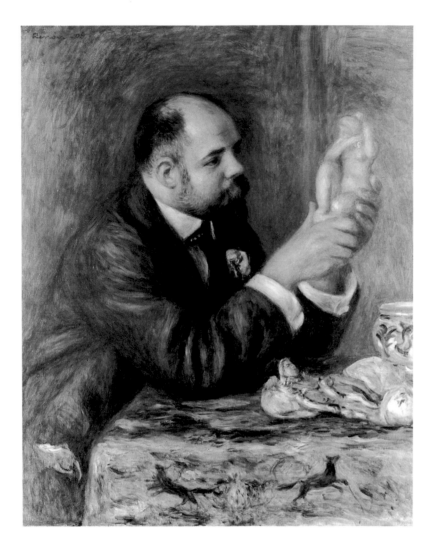

28. *Ambroise Vollard,*
1908. Oil on canvas;
81.6 x 65.2 cm.
Courtauld Gallery,
London, Samuel
Courtauld Collection.

Essoyes, visiting Paris seldom and no longer traveling abroad.

The south was not only beneficial for Renoir's health, but it was also particularly nurturing for his work. His move there inspired a more strongly felt classicism. In his writings, one of Renoir's friends, critic Téodor de Wyzewa, reflected current ideas about the psychological and characterological differences between north and south that were clearly close to Renoir's own: the north, Wyzewa advanced, is for the young, for people "eager for movement and struggle. . . . But sooner or later, the sun attracts them . . . calms their nerves . . . and opens their eyes to the splendor of eternal things." It was the "eternal things" that Renoir now increasingly sought to express, taking Monet to task for painting "times of the day" rather than "an eternal hour." And so he abandoned fashionable costume pieces in favor of nudes in landscape settings, executed in a palette that grew warmer as the new century progressed (see pl. 26). Certainly his nerves were calmer, as he had finally resolved for himself the conflict between painting *en plein air* and in the studio, as well as between "objective" and "subjective" approaches to the model. Typically, Renoir expressed the idealism he now sought in his art with a seemingly contradictory crudeness: "I could not do without a model, but one has to

health problems, notably rheumatoid arthritis, which had been bothering him for years. Beginning in 1899, this affliction prompted annual sojourns in the healing climate of the south. In 1907 he and Aline bought property and built a house at Cagnes, just west of Nice, thereafter dividing their time between Cagnes and

know how to forget the model, otherwise the work will smell of armpits." But it was his earthiness that ensured that Renoir's impetus towards idealization would retain the sensuality—the physicality—echoed in his avowal: "I like a painting which makes me want to stroll in it, if it is a landscape, or to stroke a breast or a back, if it is a figure."

Renoir died in 1919, and for the last decade of his life he worked under acute physical handicaps. By 1910 his arthritis was so severe that he no longer walked and had to be carried out of doors on a chair to paint with hands that were increasingly crippled. In 1912 he had a stroke and suffered some paralysis. And yet, to the end, he persisted in making art. Thanks to the encouragement—and ambitions—of Vollard, he even undertook new challenges. After 1900 Vollard had become, along with Durand-Ruel and, later, Bernheim-Jeune, one of the three principal dealers to handle Renoir's work. Since the competition for Renoir's art was considerable, and Durand-Ruel's position preeminent, Vollard looked for new ventures for the artist, in which he would have exclusive rights. To this end, he suggested that Renoir undertake sculpture. Renoir was aware of Vollard's interest in the medium, and acknowledged it in his 1908 portrait of the dealer showing him holding a statuette by Aristide Maillol of a crouching

woman (fig. 28). The previous year, Vollard, who promoted Maillol's work, had commisioned the sculptor to execute a portrait bust of the painter (Fondation Dina Verney, Musée Maillol, Paris). Until that time, Renoir had evidently mistrusted Maillol, perhaps because of the similarities between the sculptor's art and his own. The statuette that Vollard holds in Renoir's portrait is close in pose to Maillol's monumental figure *The Mediterranean* (fig. 29), which had been much discussed when it was shown in 1905 at the Salon d'automne, a recently established exhibition venue for contemporary art. Renoir, who was both honorary president and an exhibitor at the event, no doubt saw *The Mediterranean* and

29. Aristide Maillol (French; 1861–1944). *The Mediterranean*, 1905. Plaster, h. 104 cm. Photograph by Eugène Druet (French; 1868–1916) of the sculpture on display at the Salon d'automne.

recognized in it shared ambitions for a monu-mental classicism, expressed in themes and forms similar to his own. Maillol is quoted as having said: "If I had continued to paint, I should have let myself be influenced by Renoir"; and he went to far as to advise an aspiring sculptor to "look at Renoir's nudes: that's real sculpture. You don't need to look elsewhere." When Renoir embarked on his own classicizing sculptures in 1913, he, in a sense, heeded this advice.

Following a plan devised by Vollard, Renoir approached the making of his sculpture in the only way his physical condition allowed. Vollard employed Richard Guino, a twenty-three-year-old Spanish sculptor who had been working for Maillol, to be the "hands" in the service of Renoir's "eyes." Their collaboration, unimpeded by the fact that they did not speak the same language, was extraordinary. Renoir's son Pierre later described the procedure:

> A sketch on paper or canvas by Renoir would furnish the general set-up of the mass of clay. With a light wand the old man would indicate how work was to continue, at one place making a mark on the maquette where the modeling tool of the young sculptor was to cut away an excessive volume, at another place showing by a pass through the air how the contour was to swell out by the addition of more material—

which the nimble fingers of the assistant molded on until the desired form was achieved. . . . They communicated by grunts when the thing got so close to the definitive result that it grew exciting.

Renoir's sculpture *Water* (pl. 25) testifies to the success of this joint endeavor and suggests that Renoir's work in sculpture may have, in turn, had an impact on his painting. The subject clearly derives from compositions featuring washer-women that Renoir had been working on only recently (see fig. 30). In these Renoir trans-formed the daily chore of washing clothes into an act of almost ritualistic significance, per-formed with deliberate gestures by women of monumental stature. In *Water* this mythologizing tendency is taken further: the kneeling woman is nude, stripped of signs of contemporary refer-ence; the smooth, lustrous, dark surface of the bronze further distances the figure from the world of appearances represented by color; and her action, pulling up the wet material, seems frozen in time.

Subjects such as this now assumed great personal meaning for the artist. Jean Renoir quoted his father as having said: "The best thing for [women] is to stoop down . . . to do the wash-ing; their bellies need this movement." This unequivocal view of femininity was being chal-lenged even as he expressed it, at a time when

the women's-rights movement was making major strides toward parity. The graphic and adamant manner in which Renoir stated his opinions reveals the degree to which the self he had constructed—a sort of rough, rustic, natural being in touch with eternal truths, a man who spoke his mind—was mobilized against the new century and its changes. As always, Renoir's art speaks with more poetry. The title of this sculpture suggests that the artist associated his beliefs about woman's "true" destiny with an elemental principle. In *Water* he clothed the female nude in the mantle of Venus, born from the foam, and, like the sea, the source of life. Water, then, is the female principle, in opposition to fire, symbol of male creativity (for his sculpture *Fire*, made at the same time as *Water*, he used the figure of a blacksmith).

Renoir had embarked on specifically mythological subjects around 1908, when he undertook *The Judgment of Paris* (private collection, Japan), the first of several painted and sculpted versions of the theme. These works attest to Renoir's admiration for Rubens (whose painting of the subject he had seen in Madrid) and Titian. But the subject also seems to have had personal significance. For Paris, in choosing Venus over Minerva and Juno, opts for love and beauty over wisdom and riches. Renoir had made a similar choice, and celebrated his personal credo over

30. *Washerwomen,* c.1912. Oil on canvas; 65 x 55 cm. Private collection.

and over in his last works. He evoked the Greeks who, as he commented, "imagined that the gods came down to earth to find their paradise and to make love. Yes, earth was the paradise of the gods. That is what I want to paint."

This was his intent in works like *Seated Bather* (pl. 26). Placed in a generic landscape setting, Renoir's vision of womanhood has now

assumed heroic proportions. But this female is as passive as she is monumental; her inertia is suggested by the notable lack of tension in her large body and by the docile expression on her remarkably small face, which reveals no sign of affect or intelligence. Dreamily, unself-consciously, she awaits an enlivening spark. She is, quite explicitly, *all* body; its generative potential is finally her essence. This Renoir underscored by reiterating her association with water, the stream of life, and by "trying to fuse the landscape with my figures" in a manner that "the Old Masters never attempted." The unity the artist sought, in this period of physical decline, was not atmospheric, as it had been during the Impressionist years, but rather symbolic. Neither a "real" space nor merely a backdrop, nature is represented as at one with the figure. The foliage that surrounds her is like an aura exhaled through her pores. She is objectified, placed before us not so much for our delectation as for our veneration. Renoir the creator fashioned a cult object—a descendant of prehistoric fertility goddess—before which he also worshipped.

His hands so stiffened by his illness that brushes had to be placed in them, Renoir could, as he acknowledged, "only paint broadly," but the results are remarkable for their delicacy. Here, working from the model in the glazed, open-air studio he had had built on his property

in Cagnes, the artist applied oils in extraordinarily thin layers that allow the white of the canvas and its texture to shine through. The act of painting had become invested with new significance. "I love greasy, oily paint, as smooth as possible. . . . That is why I love painting in oils," Renoir proclaimed. He was equally enamored of his finished creations: "I love to paw a painting, to run my hand across it." The background of *Seated Bather* bears signs of the artist's intense physical involvement in its making, for he seems to have rubbed—possibly with his fingers—the color across the surface. Whereas he had earlier "made love" with his brush to the decorative females it spawned, his physical attentions to the earth mothers that now preoccupied him were more frought, his "pawing" a kind of supplication. As *Seated Bather* suggests, Venus Genetrix responded to Renoir's veneration: crippled and infirm, focusing his remaining energies on his art, he became invigorated and managed to achieve works of an ambition and potency that belie his extreme frailty. There is a heroic element in late works such as this that commands our respect, even if we question the tenets on which they were based.

When Renoir died in 1919—five years after painting *Seated Bather*—he was widely regarded as the last of the Old Masters, the greatest living and most quintessentially French painter. His

earlier work, like Impressionism in general, had already joined the traditional canon, recognized in the official circles he first aspired to and then helped redefine. But now, following his death, he was discovered by the young leaders of the twentieth-century avant-garde who, recovering from the calamity of World War I, responded to the restorative character of the artist's late work and its full-blooded appeal to traditional values. Pablo Picasso included three drawings described as "after Ingres" or "after Renoir" in the large exhibition of his work organized in Paris in 1919. He also began acquiring late paintings by Renoir for his personal collection. But the homage that Renoir would probably have found most rewarding is the group of paintings Picasso produced in his so-called Neoclassical style in the early 1920s. In *Large Bather* (fig. 31) and works like it, Picasso very obviously incorporated and carried forward Renoir's lesson. Renoir himself had similarly engaged in conversations with past masters; now his art was speaking to the future.

Certainly, it is no longer possible to subscribe to some of the social and cultural beliefs that Renoir attempted to portray. Nonetheless his art still has much to offer, despite—indeed, because of—the nature of his enterprise. For, unapologetically, Renoir set out to create an art that pleases, and in this endeavor he was largely successful. Although he was aware that this strat-

31. Pablo Picasso
(Spanish; 1881–1973).
Large Bather, 1921.
Oil on canvas;
182 x 101.5 cm. Musée
de l'Orangerie, Paris,
Collection of Jean Walter
and Paul Guillaume.

egy could be called into question even by his own contemporaries, he could not have imagined the ambivalent attitudes of late-twentieth-century viewers toward an art that exalts a *joie de vivre*.

Our response today to Renoir's work is further problematized by the circulation of iconic images such as *Two Sisters* (pl. 12) in reproduced forms, which can desensitize viewers to their true expressive force. Renoir's art has been compromised—more than van Gogh's, Toulouse-Lautrec's, or even Monet's—by its popularity. Reproductions are always more faithful to a painting's subject than to its pictorial constituents —drawing, brushwork, color, and complexity of surface. The result can be like a shell of the original, drained of vitality, and, in the case of Renoir's women and children, can seem almost crudely ingratiating. This does the artist a great disservice, for, as we have seen, he devoted a lifetime of labor to the craft of his art, making it

central to its content. Only by standing before Renoir's pictures and responding visually and viscerally to the sensual beauties they embody can we come to understand the artist's equation of surface and substance.

Renoir's best paintings celebrate earthly delights—from the Parisian suburbs to invented Arcadias—burnishing them like cherished memories. The best of them are compellingly vivid. It has been said that "not a single woman or child painted by Renoir . . . has lost anything of their ineffable youth: no matter what the date of their hat or dress, they are so unashamedly modern that it is impossible to imagine them as grandmothers." This was written in 1892, and, more than one hundred years later, it remains true. His subjects are not flies in amber; they continue to live and breathe and to engage us. Finally, this is Renoir's great achievement.

Plates

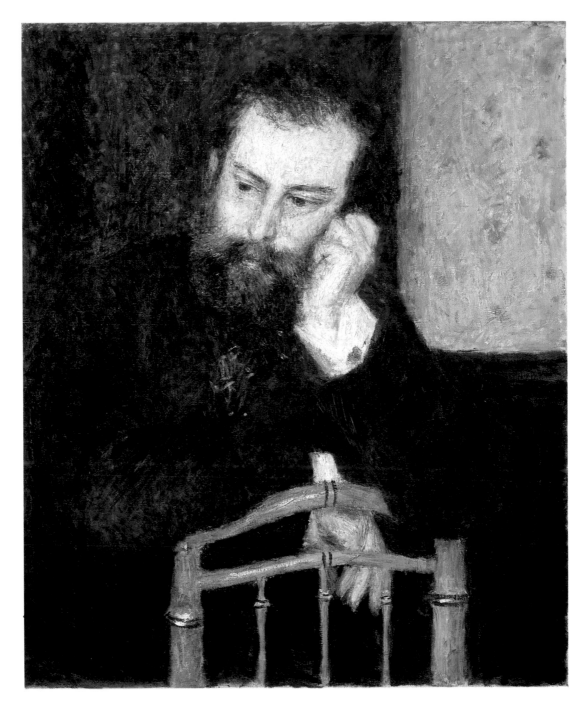

1. Alfred Sisley

1875/76

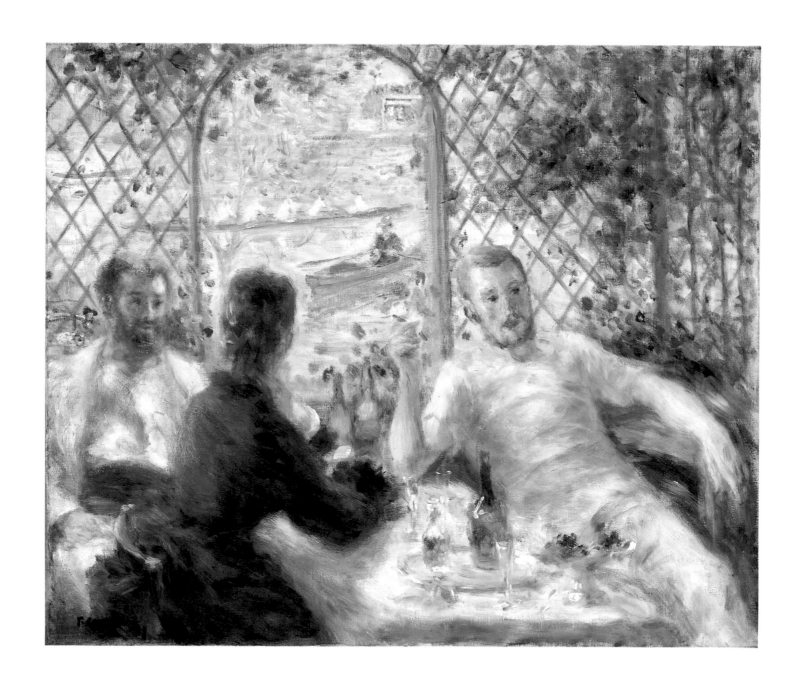

2. Lunch at the Restaurant Fournaise (The Rowers' Lunch)

1875

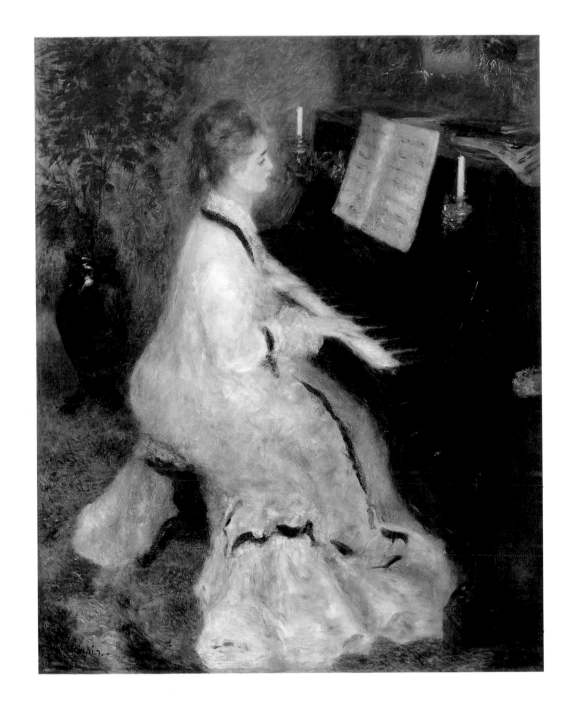

3. Woman at the Piano

1875/76

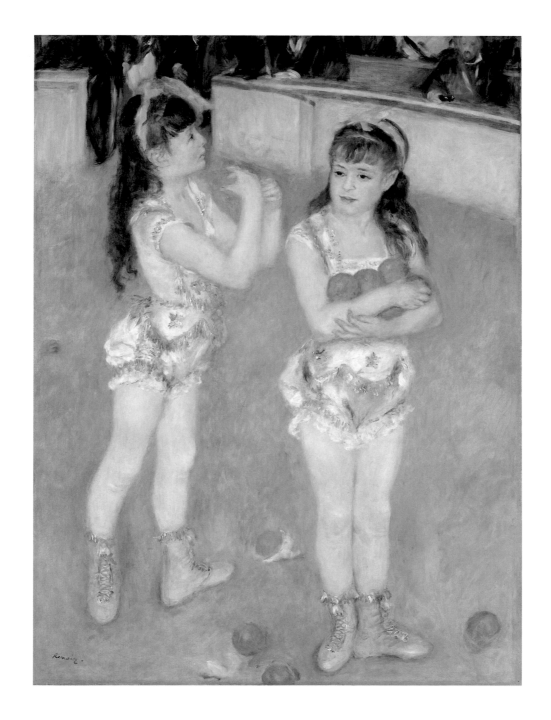

4. Acrobats at the Cirque Fernando (Francisca and Angelina Wartenberg)
1879

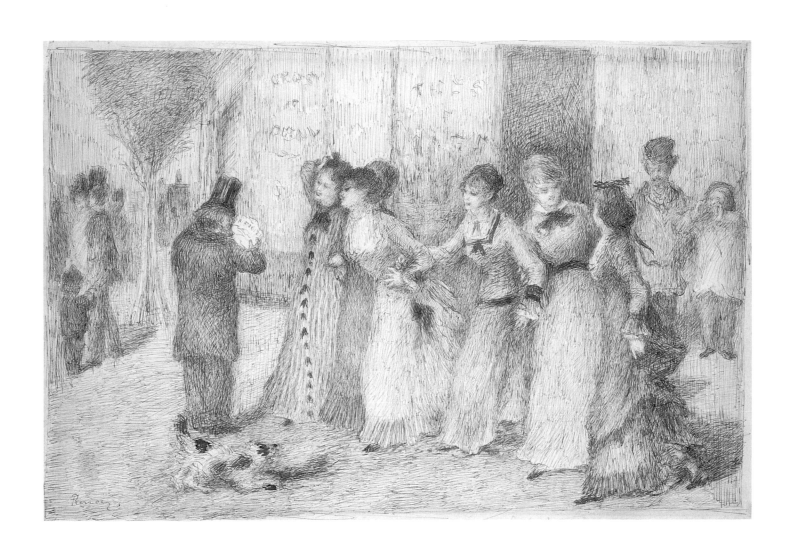

5. Workers' Daughters on the Boulevard
(Illustration for Emile Zola's "L'Assommoir")
1877/78

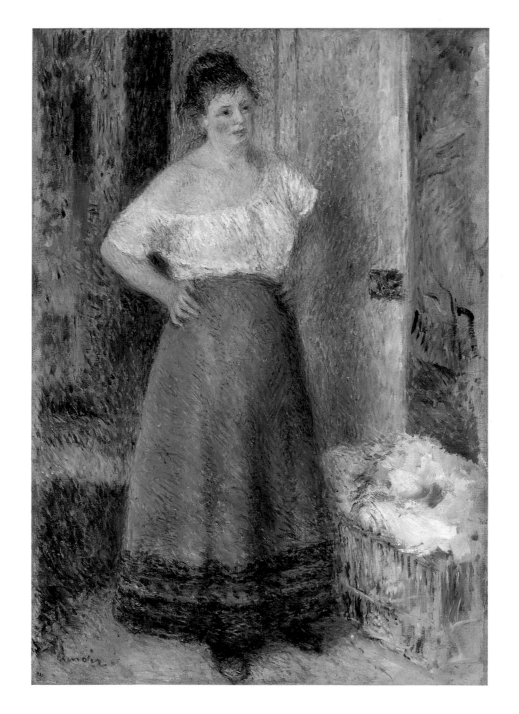

6. The Laundress

1877/79

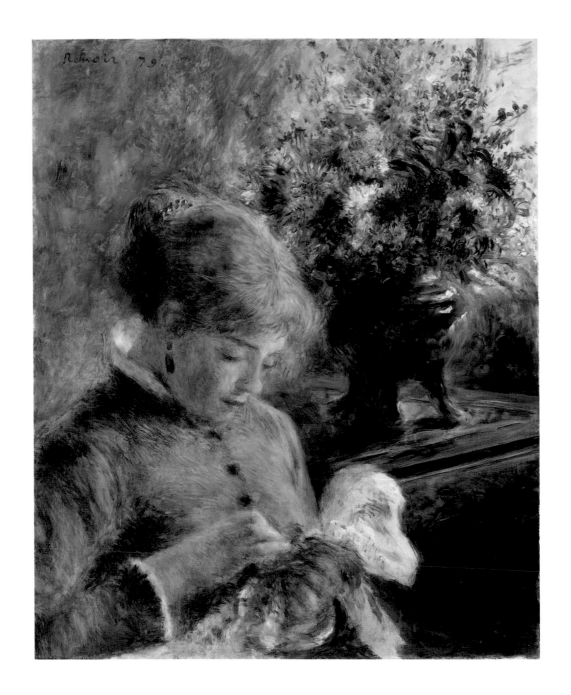

7. Young Woman Sewing

1879

8. Seascape

1879

9. On the Terrace of a Hotel in Bordighera: The Painter Jean Martin Reviews His Bill
(Illustration for Edmond Renoir's short story "L' Etiquette")

1881

10. The Descent from the Summit: Jean Martin Steadies Hélène, the Banker's Daughter
(Illustration for Edmond Renoir's short story "L' Etiquette")

1881

11. Near the Lake

1879/80

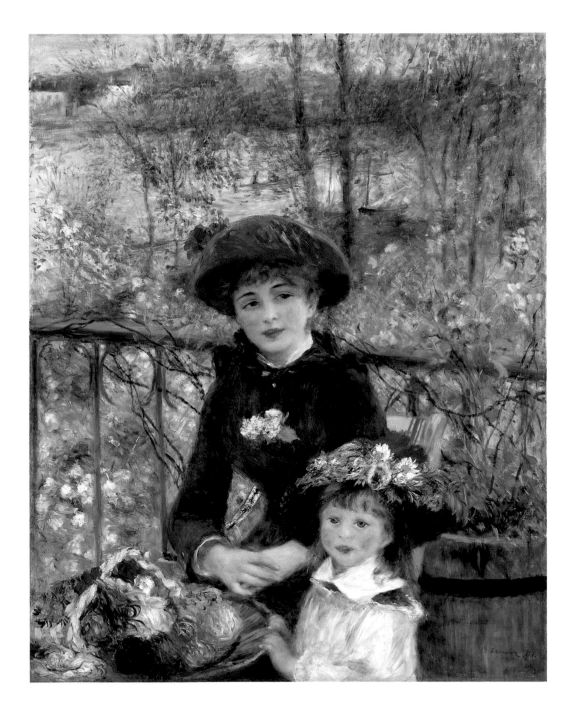

12. Two Sisters (On the Terrace)

1881

13. Fruits of the Midi

1881

14. Chrysanthemums

1881/82

15. Mme Clapisson (Lady with a Fan)

1883

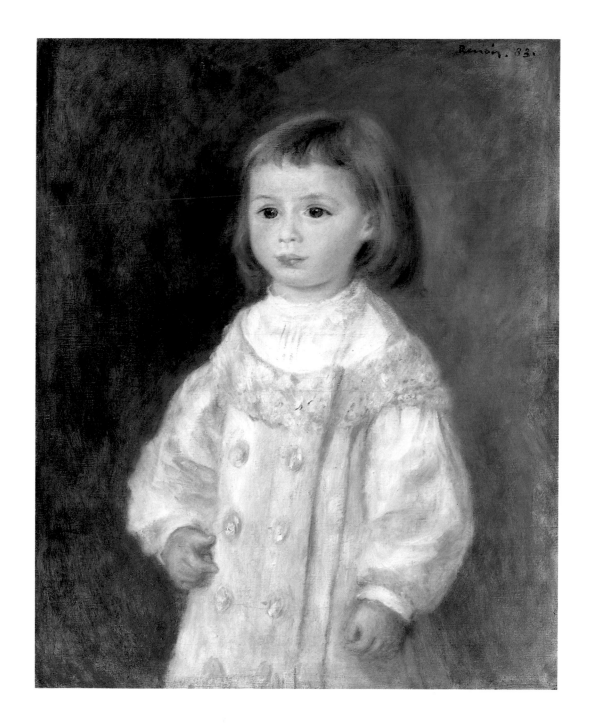

16. Lucie Berard (Child in White)

1883

17. Splashing Figure (Study for "The Great Bathers")
1884/87

18. Studies of Trees and Foliage

1884/87

19. Studies of Pierre Renoir; His Mother, Aline Changot; Nudes; and Landscape

1885/86

20. Grove of Trees

1888/90

21. Jean Renoir Sewing

1898/99

22. Pinning the Hat

1898

23. *Paul Cézanne*

1902

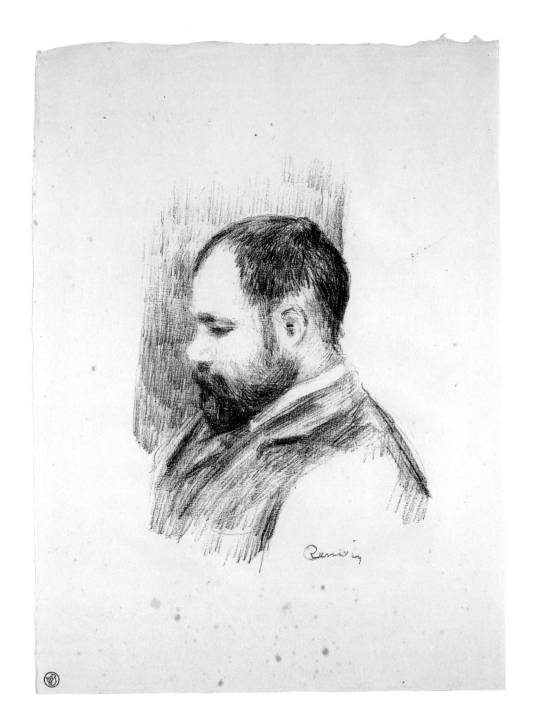

24. Ambroise Vollard

1904

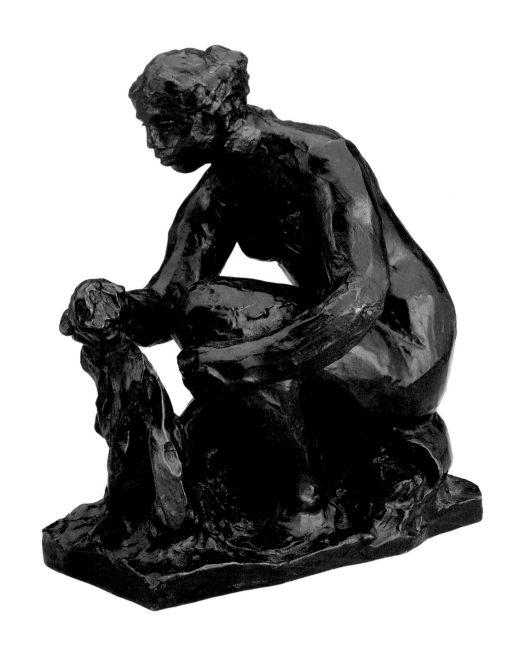

25. Water

1916

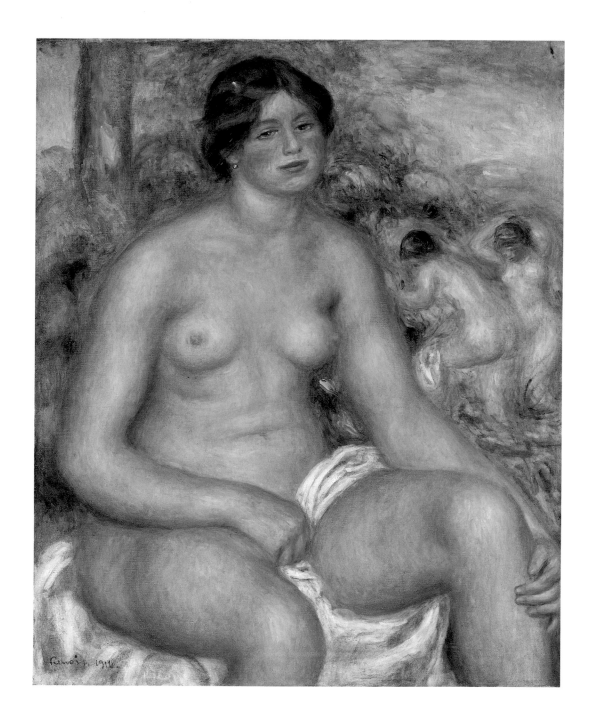

26. Seated Bather

1914

Checklist

1. *Alfred Sisley*
1875/76
Oil on canvas; 66.4 x 54.8 cm
Mr. and Mrs. Lewis Larned Coburn Memorial
Collection, 1933.453
Ill. p. 82

2. *Lunch at the Restaurant Fournaise*
(The Rowers' Lunch)
1875
Oil on canvas; 55.1 x 65.9 cm
Potter Palmer Collection, 1922.437
Ill. p. 83, detail p. 8

3. *Woman at the Piano*
1875/76
Oil on canvas; 93.2 x 74.2 cm
Mr. and Mrs. Martin A. Ryerson Collection,
1937.1025
Ill. p. 84, detail p. 15

4. *Acrobats at the Cirque Fernando (Francisca*
and Angelina Wartenberg)
1879
Oil on canvas; 131.5 x 99.5 cm
Potter Palmer Collection, 1922.440
Ill. p. 85, detail frontispiece

5. *Workers' Daughters on the Boulevard (Illustration*
for Emile Zola's "L'Assommoir")
1877/78
Pen and brown ink over black chalk on ivory
laid paper; 27.5 x 39.9 cm
Regenstein Collection, 1986.420
Ill. p. 86, detail p. 25

6. *The Laundress*
1877/79
Oil on canvas; 81.4 x 56.5 cm
Charles H. and Mary F. S. Worcester
Collection, 1947.102
Ill. p. 87, detail p. 108

7. *Young Woman Sewing*
1879
Oil on canvas; 61.5 x 50.3 cm
Mr. and Mrs. Lewis Larned Coburn
Memorial Collection, 1933.452
Ill. p. 88

8. *Seascape*
1879
Oil on canvas; 64.8 x 99.2 cm
Potter Palmer Collection, 1922.438
Ill. p. 89, detail p. 33

9. *On the Terrace of a Hotel in Bordighera:*
The Painter Jean Martin Reviews His Bill
(Illustration for Edmond Renoir's short
story "L'Etiquette")
1881
Pen and brush and black ink with black conté
crayon on cream laid paper; 45.2 x 35.4 cm
Helen Regenstein Collection, 1977.491
Ill. p. 90

10. *The Descent from the Summit: Jean Martin*
Steadies Hélène, the Banker's Daughter
(Illustration for Edmond Renoir's short
story "L'Etiquette")
1881
Black conté crayon with touches of black
pastel on cream laid paper; 49.2 x 31.8 cm
Gift of Mr. and Mrs. B. E. Bensinger,
1969.870
Ill. p. 91

11. *Near the Lake*
1879/80
Oil on canvas; 47.5 x 56.3 cm
Potter Palmer Collection, 1922.439
Ill. p. 92, detail p. 81

12. *Two Sisters (On the Terrace)*
1881
Oil on canvas; 100.5 x 81 cm
Mr. and Mrs. Lewis Larned Coburn
Memorial Collection, 1933.455
Ill. p. 93, detail p. 43

13. *Fruits of the Midi*
1881
Oil on canvas; 50.7 x 65.3 cm
Mr. and Mrs. Martin A. Ryerson Collection,
1933.1176
Ill. p. 94, detail p. 53

14. *Chrysanthemums*
1881/82
Oil on canvas; 54.7 x 65.9 cm
Mr. and Mrs. Martin A. Ryerson Collection,
1933.1173
Ill. p. 95, detail p. 63

15. *Mme Clapisson (Lady with a Fan)*
1883
Oil on canvas; 81.8 x 65.2 cm
Mr. and Mrs. Martin A. Ryerson Collection,
1933.1174
Ill. p. 96

16. *Lucie Berard (Child in White)*
1883
Oil on canvas; 61.7 x 50.4 cm
Mr. and Mrs. Martin A. Ryerson Collection,
1933.1172
Ill. p. 97

17. *Splashing Figure (Study for "The Great Bathers")*
1884/87
Red, white, and black chalk and black conté
crayon, with brush and red- and white-chalk
wash on tan tracing paper, laid down on
canvas; 98.9 x 63.5 cm
Bequest of Kate L. Brewster, 1949.514
Ill. p. 98

18. *Studies of Trees and Foliage*
1884/87
Pen and black ink with watercolor on ivory
wove paper; 49.5 x 30.8 cm
Gift of Mrs. Potter Palmer, 1948.75
Ill. p. 99, detail p. 71

19. *Studies of Pierre Renoir; His Mother;*
Aline Charigot; Nudes; and Landscape
1885/86
Oil on canvas; 46.1 x 39.2 cm
Restricted gift of the Phillips Family
Collection, 1983.1
Ill. p. 100

20. *Grove of Trees*
1888/90
Watercolor with gouache on ivory wove paper;
24.6 x 17.9 cm
Bequest of William McCormick Blair,
1982.1827
Ill. p. 101

21. *Jean Renoir Sewing*
1898/99
Oil on canvas; 55.4 x 46.5
Mr. and Mrs. Martin A. Ryerson Collection,
1937.1027
Ill. p. 102

22. *Pinning the Hat*
1898
Color lithograph on ivory laid paper;
76.9 x 62.5 cm
Anonymous gift, 1938.1260
Ill. p. 103

23. *Paul Cézanne*
1902
Lithograph on grayish-ivory wove paper;
39 x 31.6 cm
Bequest of Mrs. Elma M. Schniewind,
1955.531
Ill. p. 104

24. *Ambroise Vollard*
1904
Lithograph on ivory wove paper; 36.8 x 26.7 cm
Gift of Walter S. Brewster, 1951.79
Ill. p. 105

25. Auguste Renoir and Richard Guino (Spanish;
1890–1973)
Water
1916
Bronze; 27.3 x 23.5 x 14 cm
Estate of Maribel G. Blum, 1986.236
Ill. p. 106

26. *Seated Bather*
1914
Oil on canvas; 81.6 x 67.7 cm
Gift of Annie Swann Coburn to the Mr. and
Mrs. Lewis Larned Coburn Memorial
Collection, 1945.27
Ill. p. 107

Selected Bibliography

Much of this text is based on the information contained in the publications listed below. The author is particularly indebted to the insightful scholarship on the subject of Renoir found in the work of Colin Bailey, Anthea Callen, Anne Distel, and John House.

Callen, Anthea. *Renoir.* London, 1978.

Daulte, François. *Auguste Renoir: Catalogue raisonné de l'oeuvre peint.* Vol. 1, *Figures, 1860–1980.* Lausanne, 1971.

Haesaerts, Paul. *Renoir, Sculptor.* New York, 1947.

London, Hayward Gallery; Paris, Réunion des Musées nationaux; and Boston, Museum of Fine Arts. *Renoir.* Exh. cat. by John House and Anne Distel, with an essay by Lawrence Gowing. 1985.

Ottawa, National Gallery of Canada; The Art Institute of Chicago; and Fort Worth, Kimbell Art Museum. *Renoir Portraits: Impressions of an Age.* Exh. cat. by Colin B. Bailey, with essays by Linda Nochlin and Anne Distel. 1997.

Pach, Walter. *Queer Thing, Painting: Forty Years in the World of Art.* New York, 1938.

Renoir, Jean. *Renoir, My Father.* Trans. by Randolph and Dorothy Weaver. Boston, 1962.

Rewald, John. *Renoir Drawings.* New York, 1946.

Rivière, Georges. *Renoir et ses amis.* Paris, 1921.

Roger-Marx, Claude. *Les Lithographies de Renoir.* Monte Carlo, 1951.

Sydney, Art Gallery of New South Wales; Brisbane, Queensland Art Gallery; and Melbourne, National Gallery of Victoria. *Renoir: Master Impressionist.* Exh. cat. by John House, with essays by Kathleen Adler and Anthea Callen. 1994.

Vollard, Ambroise. *Renoir: An Intimate Record.* Trans. by Harold L. Van Doren and Randolph T. Weaver. New York, 1925.

Wadley, Nicholas, ed. *Renoir: A Retrospective.* New York, 1987.

White, Barbara Erlich. *Renoir: His Life, Art, and Letters.* New York, 1984.

Zola, Emile. *L'Assommoir.* Trans. by L. W. Tancock. Hammondsworth, 1970.